The Hasselblad System
by Bob Shell

The Hasselblad System
by Bob Shell

PRO GUIDE

The Hasselblad System

by Bob Shell

HOVE FOTO BOOKS

The Hasselblad System
Bob Shell

The PRO Series
Series editor: Bob Shell
Editor: Dennis Laney
Typesetting and layout: Annida's Written Page, Shoreham, Sussex
Printed in Scotland by:
Eagle Colourbooks Ltd., Glasgow.
First published in Great Britain 1991 by:

HOVE FOTO BOOKS
34 Church Road
Hove, Sussex
BN3 2GJ, England

British Library Cataloguing in Publication Data
Shell, Bob
 The Hasselblad system.
 1. Medium format single lens reflex camera. Techniques
 I. Title
 771.32
 ISBN 0906447771

U.K. Trade Distribution:
Newpro (UK) Ltd
Old Sawmills Road
Faringdon, Oxon
SN7 7DS
FAX: 0367 241124

U.S.A. Distribution:
The Saunders Group
SATTER INCORPORATED
4100 DAHLIA STREET P.O.BOX 7234
DENVER COLORADO 80207 U.S.A.
Fax : (303) 322 8152
FAX: 716 328 5078

This publication is not sponsored in any way by Victor Hasselblad AB. Information, data and procedures in this book
are correct to the best of the author's and publisher's knowledge. Because use of this information is beyond author's
and publisher's control, all liability is expressly disclaimed. Specifications, model numbers and operating procedures
may be changed by the manufacturer at any time and may, therefore, not always agree witht he content of this book.

Contents

ACKNOWLEDGEMENTS

This book would not have been possible without the generous help of many people. I wish to express my sincere thanks to everyone who assisted, and particularly to the following:

The person who should be thanked first is Gustav Lagergren of Victor Hasselblad Aktiebolag in Gothenburg, Sweden, who first conceived the project, and assisted in great detail at every step of its preparation. Without Gustav's generous help this book would not exist.

Here in the USA, I would particularly like to thank Skip Cohen and Ernst Wildi of Victor Hasselblad Inc., for their assistance in providing information and particularly for the loan of Hasselblad equipment used in the preparation of this text. I would also like to thank Richard Perry who works with Hasselblad for his generous help.

Because I wanted this book to represent the broad spectrum of photography done with Hasselblad cameras, I solicited photographs from other photographers to include in the book. I want to thank each and every photographer who went to the trouble to send material to me, the response was overwhelming with more than 250 photographers submitting work. Obviously we could not use all of the images in the book, but they were uniformly of excellent quality, and often the choice of which to use had to be made on considerations of space available. I hope the photographers whose work is reproduced here will be pleased with the presentation, the selection process was difficult.

I would like to give a special thank-you to Dr. Robert Deans, long-time Hasselblad photographer, who produced some spectacular images of the orchids he grew. Bob Deans gave me a selection of his photos from which to pick, and expressed the wish that he would live to see the book. Alas, that was not to be, but his photos stand as a tribute to his talent and vision.

Firms throughout the photographic industry have been helpful by supplying product samples or other support used in the preparation of this book. These firms are: Photoflex, Fuji Photo Film, USA, Eastman Kodak Company, Polaroid Corporation, Agfa-Gevaert, The Saunders Group, Heico Inc., Sailwind Products, Bogen Photo Corporation, Bromwell Marketing, and other photo industry friends too numerous to list.

PFS Photofinishing helped greatly by processing the film used in my work with the Hasselblad system. I thank them for their excellent and speedy work.

The last, and always the most important, acknowledgement goes to my wife, Darlene, for having the grace to put up with me during the sometimes difficult times of writing the book. Without her support, the book would have died several times.

Bob Shell
Radford, V.A.
August, 1991

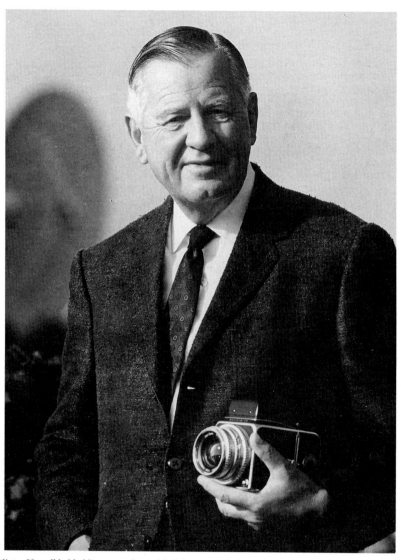

Victor Hasselblad holding an early model of the camera he brought to life.

1: The Hasselblad Design Philosophy

The Hasselblad system was, from the very beginning, conceived as a fully modular system, one in which lenses, film backs, viewing systems, and all accessories could be easily and quickly switched from body to body and configured in exactly the proper way for the type of photography to be done. Such system flexibility is taken for granted today, but it was the exception when the first Hasselblad came on the scene.

Central to the system and the philosophy is the camera body. This is basically a box containing reflex mirror, focusing screen, lens mount with actuating mechanisms, film back mount with actuating mechanisms and either a light baffle or focal plane shutter depending on camera model. The key design criteria for the Hasselblad body have always been simplicity and rugged dependability as well as small size. Many people are still amazed today to find that a fully outfitted Hasselblad is in many cases smaller and lighter than a professional 35mm system camera.

Prior to turning to production of cameras for professional and amateur use, the Hasselblad company had produced a series of aerial cameras for the Swedish Government, beginning in 1941 with the HK7. In the early 1940's, the decision was made to produce a general purpose camera, and a series of prototypes were built. Originally the camera was to be called ROSSEX, but that name had already been registered as a trademark in several countries and had to be abandoned in favor of the company name, Hasselblad. Work on these prototypes proceeded during the war, and the final version was carried through to production form and introduced as the 1600F in 1948.

The original production Hasselblad bodies, the 1600F and 1000F, were fitted with a shutter which used corrugated stainless steel curtains operated by silk tapes. This shutter proved to be unsatisfactory in heavy use, causing frequent breakdowns, and was discarded in favor of a much more dependable Compur-made leaf shutter mounted internally in the lenses. The "F" designation in these model numbers stands for Focal plane shutter, while the number indicates maximum shutter speed. When the F-series of cameras was superceded by the newer version

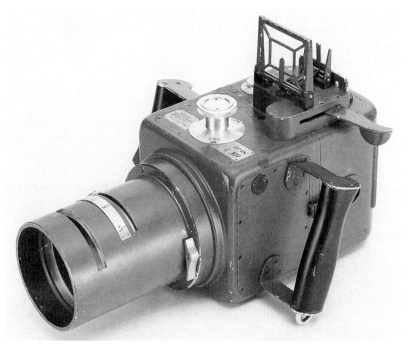

The HK7, one of the first photographic products produced by the company.

using shutters in the lenses, the model designation reflected the change, with the new camera called 500C, "500" indicating that the maximum shutter speed was now 1/500 second and "C" indicating the use of the Compur shutter.

The wisdom of this change has been proven by the test of time, the Compur shutters and the 500C bodies have an enviable record for durability and longevity in hard professional use. The switch to the Compur (later Prontor) shutter, which is an inter-lens leaf shutter, also resulted in improved operation with electonic flash, which can be synchronized at all shutter speeds.

When the original Hasselblad cameras were introduced they featured lenses from Eastman Kodak in the USA, Carl Zeiss Jena in East Germany, and Carl Zeiss in West Germany. With the change to the Compur shutters, all lenses were taken from Carl Zeiss in West Germany, with a few lenses in recent years coming from Joseph Schneider in Kreuznach. While the lenses from Eastman Kodak and East Germany were excellent performers, the later lenses from Carl Zeiss in West Germany set new

standards against which all other medium format lenses have been judged. A constant program of updating and redesign has kept these lenses at the pinnacle of the lens maker's art. One reason so many professional photographers use the Hasselblad system is the unsurpassed optical quality of the lenses offered in the system.

Most recently, due to a desire from certain photographers for higher shutter speeds, Hasselblad has designed a new series of cameras utilizing a modern focal plane shutter. These new cameras are designed so that they will work with the existing Compur-shuttered lenses, a newer range of CF lenses which feature a new Prontor leaf shutter, and a range of F

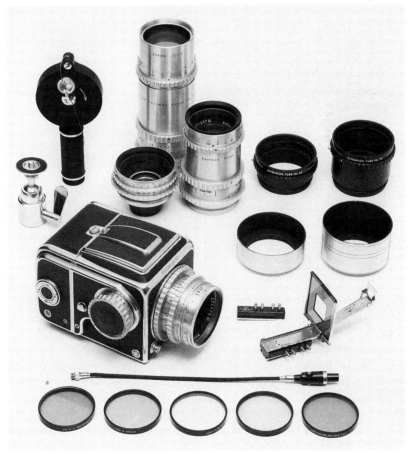

The Hasselblad 1600F with its accessories, the first Hasselblad system

and TCC lenses which do not have internal shutters. The F and TCC lenses can be used only with the FC series and 205TCC cameras, since the C-series cameras have no shutter in the camera body.

The 2000FC was the first of the new F-series cameras, featuring a titanium foil shutter which is moved by strong cables and has proved to be reasonably durable, but still somewhat troublesome in professional use. Because the shutter curtains are exposed to possible damage when the film back is removed, a modified 2000FCM was introduced in which the shutter automatically withdraws when the magazine is removed. The last version was the 2000FCW, which accepts an optional motor winder for motorized film advance.

Most recently, Hasselblad has again gone back to the drawing board and re-designed the focal plane shutter once again. This time they have developed a shutter using more traditional rubberized textile curtains, and it is hoped that this shutter, introduced in the 205TCC, will finally produce the long-term durability they have been seeking in a focal plane shutter design.

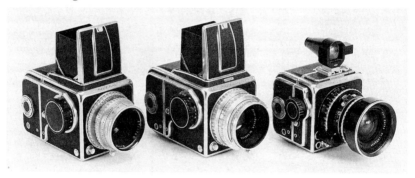

The first three Hasselblad cameras. On the left is the 1600F of 1948, in the centre is the 1000F of 1953, and on the right is the original Super Wide of 1954.

Developed in parallel with the 500C series of camera bodies is a second series called the EL series. The 500EL cameras are essentially the same as a 500C but with a permanently attached motor drive built onto the bottom. The original 500EL and its successors were powered by a special rechargeable NiCd battery which could be charged in the camera or in an external charger. The latest 500ELX has been modified so that it will also operate from standard alkaline AA cells for those who do not use the camera often enough to keep the NiCd batteries in proper condition, or for times when the NiCd runs down and it needs emergency power.

Also paralleling the other cameras is a special wide-angle camera called the SWC. When first offered, this camera was called Hasselblad Supreme Wide Angle and featured a separate shutter cocking and film winding systems. Later the film advance and shutter cocking were

Hasselblad 903SWC

linked and the camera was renamed the Super Wide C, often referred to as SWC. This camera features a special 38mm Zeiss Biogon lens which is a permanent part of the camera body and nearly touches the film at the rear. Viewing is by means of an optical finder atop the camera, and focus by scale. In 1979 the SWC was redesigned so that it would accept Polaroid magazines, and renamed the SWC/M, and in 1988 a further redesign was

done to improve the viewfinder, which now features a spirit level visible through the finder.

The SWC camera was made because the optical quality of the Biogon, which is not a retrofocus design, is far better than the quality which could be gotten from a retrofocus design such as the original 40mm Distagon for the reflex cameras. However, progress in optical design has really overcome this problem, and the latest version of the 40mm Distagon appears in my tests to be equal to the Biogon in performance.

These are the basic camera bodies of the Hasselblad system. All except for the early F series are, in my opinion, suitable for current professional use. I even know a photographer or two who stubbornly hang onto F cameras, proving that not all of these shutters were quite so trouble prone.

When buying used Hasselblad equipment, it is important to understand what fits what, and what the differences are in the cameras. For example, there were many thousands of 500C cameras built. The earliest ones are distinguished by two sockets on the front of the camera. Later

Hasselblad Film Magazine 70. This magazine has a capacity of 70 exposures with an image size of 55x55mm (2 1/4 x 2 1/4 inches).

ones lack these sockets, but still have factory-installed non-interchangeable focusing screens. The 500CM differs in having interchangeable focusing screens, and since the focusing screens on early Hasselblads are notoriously dim, I would recommend against purchase of models without user-interchangeable screens. Any 500CM will accept the newest, and much improved screens which make focusing far easier, particularly in dim light.

There have been several versions of the basic twelve-exposure film magazine. The earliest ones, made for the F-series cameras, can only be used on those cameras. These magazines have serial numbers lower than 20,000 and lack the socket for a small release pin which activates the frame counter on later magazines (see illustration). All magazines of any vintage may be used on the F-series cameras.

Internally the film magazines have a film support which slides out of the left-hand side of the magazine when a release latch is turned. In the early magazines, there is a funnel shaped tube through the film insert,

Extremes in fashion, hair style, jewellery, etc. are best portrayed with simple backgrounds. Hasselblad photographers enjoy the best of all worlds: they can crop their pictures to landscape or portrait formats, or they can exploit the square format and find subjects for which it is right. (Photo by Fay Sharpsteen).

and a door in the back of the magazine body. This door is opened when loading and the film is run forward until the number 1 on the film backing paper is visible through this opening. This must be done with the magazine carefully shaded, as light can penetrate this tunnel and cause film fogging.

This magazine design was changed to the improved version in which the film start arrows on the film back need only be lined up with a start mark before the film insert is slipped into the magazine, and then the winding knob or crank is turned and the film advance will automatically stop at frame one.

While the older magazines will work fine with any camera, I'd suggest avoiding them because they are a nuisance to load and the newer ones are not that much more expensive.

Since 1985 a newer type of film insert has been used which features a system to maintain film tension for better flatness. These new magazines are easily distinguished by having a single arm with both spool retainers mounted on the ends instead of separate hinged arms for each film spool retainer.

If buying used magazine backs, it is important to check that the last three digits of the serial number on the insert and back are the same because these are factory matched and a mismatched magazine may not function properly.

Space Shuttle Columbia. (Photo by Mark Vsciak).

Even when used directly into the sun, the Zeiss lenses for the Hasselblad show remarkably little flare. Photo: Mitch Carucci.

2: The Hasselblad 500C Series

While the 1600F and 1000F cameras had received a good reception from working professional photographers, the stainless steel corrugated shutter had proved to be troublesome in heavy professional use, and the relatively slow flash synchronization speed was limiting to those wishing to use outdoor fill flash. To overcome these problems, Hasselblad

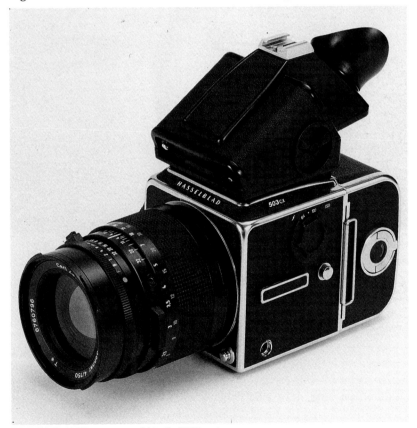

Hasselblad 503CX, current model in the 500C-series

Advertising shot by Bill Deodato

designed a totally new camera in collaboration with Carl Zeiss and Compur.

This new camera was introduced in 1957 as the 500C, the "C" standing for Compur, and featuring Compur-built interlens shutters. These shutters had already established an excellent reputation in use by view camera photographers and in some 35mm cameras, so Hasselblad could feel confidence in the reliability of the new system. The original Compur shutter was used until 1976 when it was replaced by a new shutter manufactured by Prontor (who had taken over Compur in the meanwhile). The lenses for the 500C were all initially built by Carl Zeiss in West

If used with care to avoid distortion, the Superwide can produce some really excellent architectural photographs. This night time exposure was taken by Rich Allred.

Germany, with some lenses from Schneider being added later to fill some gaps, and all the shutters were built by Compur.

The 500C body was considerably simplified from the 1600F and 1000F cameras, since it did not contain a shutter. Basically the 500C body contained only a mirror flipping mechanism and a supplementary dark blind mechanism. This simplicity has proved to be its strength, since 500C bodies rarely fail and need little in the way of regular maintenance. Simple periodic cleaning and lubrication should keep a 500C body functioning practically forever.

Although there are only minor external differences, the 500C series has undergone considerable internal revision and refinement over the years, with the later cameras being even more dependable. Following the success of the 500C a revised version called the 500C/M was introduced

in 1970. This camera differed from the original 500C mainly in featuring user-interchangeable focusing screens. In 1984 the original standard winding knob was replaced by a rapid advance crank as standard equipment.

The current model in the 500C series is called the 503CX. It is similar to the 500C/M, but features an internal silicon metering cell which can be linked with certain flash units to offer automatic flash exposure with OTF (off the film) light measurement. Additionally, at the same time as the 503CX, a new focusing screen called Acute Matte was introduced. This focusing screen is made for Hasselblad by Minolta, and offers a considerable increase in brightness over older Hasselblad screens (however, with somewhat of a loss in contrast).

Due to very great demand, in 1989 Hasselblad re-introduced the 500C/M as the 500 Classic. This camera is essentially identical to the late 500C/M cameras.

Although some independent manufacturers have offered motor drives for the 500C series of cameras, Hasselblad has never done so. When they began research on producing a motorized camera in the early 1960's, they decided from the beginning that it was necessary to produce a separate, motor-integrated camera to insure proper motorized function. The first motorized camera, called the 500EL, was developed in early prototype form in 1961 and reached final prototype form in 1963. The

Hasselblad Anniversary 500 Classic - essentially a 500C/M

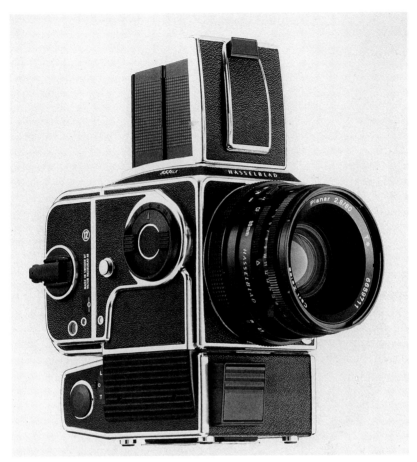

Hasselblad 553ELX

camera was introduced in 1965, along with a group of special accessories designed specifically for the camera.

Development of the 500EL cameras progressed alongside the 500C series, with the introduction in 1972 of the 500ELM with interchangeable focusing screens, and in 1984 with the 500ELX with TTL-OTF flash coupling and a larger mirror for greater viewfinder brightness. When the Acute Matte focusing screen was added and the shutter release enlarged, the camera was renamed 553ELX in 1988.

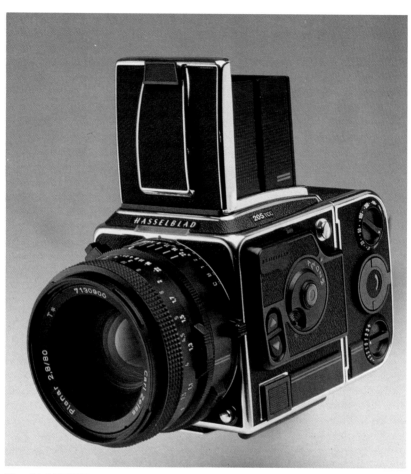

Hasselblad 205TCC

3: The Hasselblad 205TCC

At first glance, particularly from the right side, the 205TCC looks like every other recent Hasselblad, but when one looks at the left side the great difference becomes apparent. A control module extends about 1/4 inch beyond the previous profile and is fitted with controls for the new systems of this very advanced camera. While the largest visible difference is in the body, everything is new, with new lenses, magazine backs and viewfinders. All components of the new system are easily identified by the double blue bands on their left sides.

The most important feature of the 205TCC is the built-in light meter, the first time Hasselblad has built a light meter into the camera body. The meter is a highly selective spot meter which reads a central area corresponding to a 6 mm circle in the center of the viewfinder, or about 1% of the image area. Focusing screens for the 205TCC have the metering area indicated by a circle drawn with a dotted line in the center. The meter is extremely well baffled; in my informal tests it responded to light only within the marked circle and nowhere else. It is also extremely accurate, measuring the light to 1/12th of an EV. All information transfer between lens, camera body and magazine is digital for increased accuracy.

Readout for the meter and other camera functions is on an LCD panel which is just in front of the focusing screen. An automatic switch reverses this display when a prism finder is fitted so that it appears right-way-round through the prism. The display indicates both aperture and shutter speed, as well as exposure error and other information, in sharp black digital form against a white ground.

Illumination for the LCD panel comes from a small translucent area on the camera body just below the Hasselblad name on the front. For times when there is not enough light to see the display, a red light which transilluminates the LCD may be turned on with a small push button switch just to the left of the viewfinder, atop the control panel. Once activated, the light remains on until the button is pressed a second time.

The ISO value of the film in use is set on the upper dial on the magazine back, which has settings from ISO 12 to ISO 6400 in 1/3 step increments. The lower dial on the film magazine is not, as might be supposed, an exposure compensation, but operates only in the camera's **Z** mode, as will be explained later.

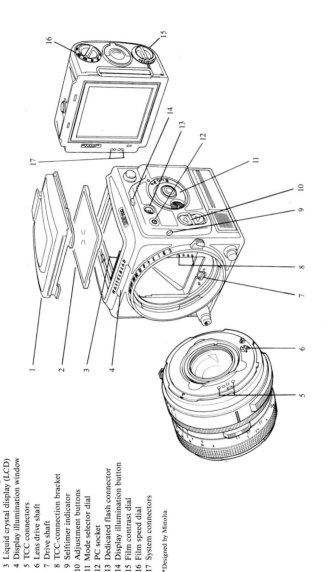

1 Focusing hood cover
2 Acute-Matte* focusing screen
3 Liquid crystal display (LCD)
4 Display illumination window
5 TCC connectors
6 Lens drive shaft
7 Drive shaft
8 TCC-connection bracket
9 Selftimer indicator
10 Adjustment buttons
11 Mode selector dial
12 PC socket
13 Dedicated flash connector
14 Display illumination button
15 Film contrast dial
16 Film speed dial
17 System connectors

*Designed by Minolta

26

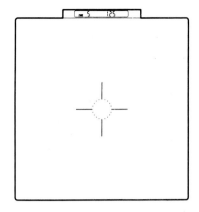

Focusing Screen of 205TCC showing position of LCD panel and spot metering area outlined by dotted line.

Centrally located on the left side of the camera body is the mode setting dial. There are four operational modes and a programming mode, sequentially identified by the designations **A, Pr, D, Z** and **M**.

The **A** mode is an automatic exposure mode utilizing aperture priority operation. When working with a TCC lens, the photographer selects the aperture desired, picks the best area of the subject from which to take a meter reading, and activates the meter. The camera then selects the correct shutter speed. Shutter speed selected by this system is displayed in the viewfinder just above the image area in an LCD panel. Speeds are displayed in 1/2 step increments, but the discrimination of the system is in 1/12 step increments and the shutter is adjusted to these very fine increments. The selected shutter speed may be locked and held prior to exposure by either pressing the shutter release button in part way, until the first detent is reached, or by pressing the **AE**-lock button in the center of the mode selector dial. The first method, a traditional **AE**-lock, required that pressure be maintained on the shutter release button to retain the reading, while the second method locks and holds the reading after pressure on the **AE**-lock button is released.

In my own photography with the camera, I found that I preferred to use the side-mounted **AE**-lock button for this purpose, as I sometimes found it difficult to maintain the requisite amount of pressure on the shutter release button without accidentally taking a photo. Either method, however, only retains the set exposure through one exposure cycle. After

ISO film sensitivity

Aperture/shutter speed settings

27

the exposure you must repeat the process, which I found inconvenient. I would have preferred to have the side button operation retain exposure until intentionally changed by the photographer.

Once the exposure has been held with the **AE**-lock button, over- or underexposure may be intentionally selected by pressing the two buttons just in front of, and slightly below the mode selector dial. The upper button will increase exposure, the lower button will decrease exposure, in both cases in 1/3 EV steps. The LCD display indicates this by a + or - numeral followed by bars. A +0 followed by one bar indicates 1/3 step overexposure, a -2 followed by two bars indicates 2 2/3 steps underexposure, and so on. It is a very simple and effective display, and one which the photographer can quickly become used to using. This method may also be used to pre-set an exposure compensation prior to exposure by simply using the over and under buttons without activating the **AE**-lock.

At the time of writing I have put about 100 rolls of film through an early production 205TCC and can say that this automatic exposure system works extremely well. Although I used all of the other modes offered by the camera, I found myself coming back to this mode because of its simplicity of operation and total reliability. The only exposures I produced which were not absolutely correct were those caused by "photographer error", that is those times when I picked an inappropriate subject area from which to meter. One of my test sessions was on a day when clouds were moving rapidly across the sky from a rather high upper level

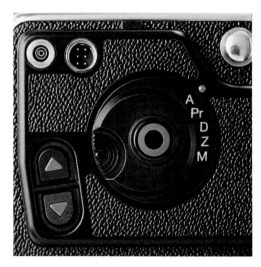

Mode setting dial, over and under exposure buttons, and six-pin dedicated and PC flash contacts, normally protected behind a cover.

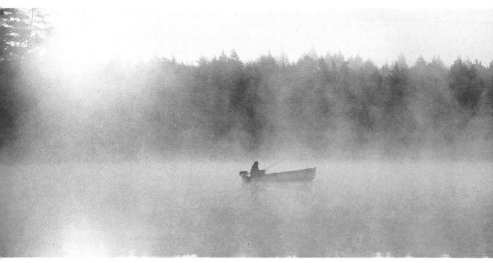

Fisherman in boat (masked in camera) - shot by Al Satterwhite

wind. The light was changing every fraction of a second, an impossible situation for a hand-held meter because the light reading would have changed before it could be transferred to the camera. By quickly taking the reading, recomposing and shooting the photo, I was able to shoot a number of rolls of film with perfect results. I should perhaps mention that nearly all of my test shooting with the camera was on color transparency film, which tolerates little error in exposure. I can say with no equivocation that this is the most accurate and sensitive in-camera meter I have ever used.

For some reason, Hasselblad has chosen to interrupt the sequence of operational modes on the mode selector dial by placing the Pr position next after the **A** position. This has confused many into thinking that this **Pr** indicates a programmed exposure mode, as in some 35mm cameras, and even some press reports indicated this. However, the **Pr** position is not an operational mode at all, but a mode for altering the camera's factory set programming to the photographer's taste. The **Pr** mode is not intended for photography, but as a fail-safe the camera reverts back to the **A** mode if an exposure is made in the Pr setting, and then returns to **Pr** after the exposure.

In the **Pr** mode there are three positions, indicated on the LCD panel by **Pr1**, **Pr2** and **Pr3**. Pressing the **AE**-lock button cycles from one to the next, and the adjustment buttons may be used to alter the pre-pro-

grammed settings. In the **Pr1** position, the dynamic range of the film may be changed. It is factory pre- programmed to a + or - 9 EV range, and functions in the **D** mode as described later. The **Pr2** position is used to change the duration of the self-timer. It is factory pre-programmed at 10 seconds, and can be set from 2 to 60 seconds in this **Pr** mode. The self timer is activated by pressing the mirror pre-release lever two times. The **Pr3** mode sets the camera's internal ISO programming. It is factory pre-set at ISO 100 and sets this value for the meter when the camera is used with a non-TCC magazine (such as the Polaroid film magazine or older Hasselblad magazines). Available settings are from ISO 12 to ISO 6400. Regardless of what ISO value is set in this manner, the use of a TCC magazine overrides it and sets the meter to the ISO value set on the magazine's ISO dial.

All of the values set by the user in the **Pr** mode are retained indefinitely as long as the camera has battery power. However, when the battery is removed or goes bad, these will all revert to pre-programmed settings.

Following **Pr** on the mode selector dial is the **D** or Differential mode. This mode allows the photographer quickly to determine the contrast range of a subject and determine if it exceeds the contrast range (dynamic range) of the film in use. In use a meter reading is first taken with the **AE**-lock button of a medium reflectance reference area, something approximating an 18% gray value. Then, as the metering spot is moved to other subject areas, the LCD display will indicate through + and - numerals and bars the number of EV increments by which these areas differ from the reference area. Once the contrast range has been determined to fall within that of the film, the exposure may be taken in the normal manner. The pre-set exposure value will be retained for subsequent exposures. Should the photographer elect to change the aperture, the camera will change the shutter speed to retain the same exposure value. Should the upper or lower contrast limits exceed those of the film, the adjustment buttons may be used to raise or lower the exposure to bring it within the film's range. It is far more complicated to explain than it is to use, and in my experience worked quite well. However, the problem may be in obtaining the information on dynamic ranges of films, since these are not commonly published by the film manufacturers on their information sheets. The photographer will have to determine these either by experiment or experience.

The **Z** or Zone mode on the Hasselblad 205 TCC may be the most confusing to most photographers. Unless the photographer already uses

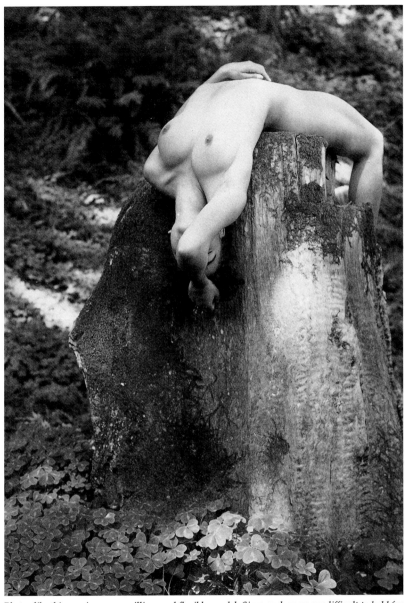

Photos like this require a very willing, and flexible, model. Since such poses are difficult to hold for any length of time, a fast and agile system such as Hasselblad is a necessity.
Photo by Steve Anchell.

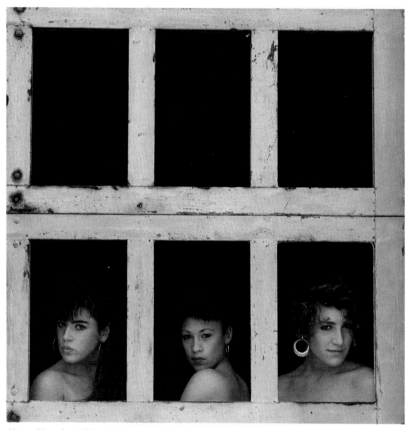

Above: Photo by Bill Deodata.

Right: Shot for Newsweek cover using 500C/M with 100mm f/3.5. Photo Al Satterwhite.

the Zone System of Ansel Adams, this mode is unlikely to be of much use, although it may make some converts to the Zone System. Basically, the Zone System takes the brightness range of a photographic image and divides it into eleven Zones. Zone 0 is total black with no detail, Zone X is total white with no detail. In between are the Zones which carry detail and form our images. Because the Zone System depends on the varying of developing as well as exposure, it is best suited for work in black-and-white. Also, because it depends on the ability to process each image in a specific manner, proper use of the Zone System is difficult with a roll film camera unless the photographer has a minimum of three film magazines. This allows the photographer to expose the film in one magazine for plus development, then in another for normal development, and in the third for minus development.

It is these variations in development which are indicated by the second, lower dial on the TCC film magazines. This is the reason that this dial only functions in the **Z** mode. In use the photographer sets the magazine for the film speed of the film in use as determined by Zone System testing. This is usually not the ISO of the film as established by the manufacturer, but is a personal exposure index determined by experiment and experience. Once this has been set, the photographer picks a middle range portion of the subject and takes a spot reading by pressing and releasing the **AE**-lock button. The camera then records this level of brightness and places it on Zone V, the middle Zone. As the camera is moved around and the spot area placed on different parts of the subject, the Zone on which the brightness of that subject will fall is displayed on the LCD panel.

If the brightness range is right, that is if the brightest area of the subject which should retain some detail falls on Zone 9 and the darkest area which should retain some detail falls on Zone I, the exposure may be made as set, and the film given normal development. However, if those areas of brightest and darkest detail do not fall within the proper zones, either plus or minus developing is called for. Changing the lower dial on the film magazine and then repeating the above process will let the photographer know exactly which sort of developing, and by what degree, is necessary to match the tones of the film to those of the subject. If other than normal development is called for, then the magazine reserved for that development can be substituted.

Actual zone value for various parts of a subject

Although the Zone System is generally not very applicable to color transparency photography, it can be used to place highlights or shadows into the correct Zones when it is known that other values are less important. For example, one well- known photographer told me that he was able to get excellent snow photographs by placing the snow on Zone VIII and allowing the rest of the image to take care of itself. There are techniques which can be used to somewhat expand or contract the tonal scale of transparency materials, and I am sure that some photographers will use the Zone mode of the 205TCC to exploit those techniques.

The Zone System can be a very confusing subject, but Hasselblad has done a good job of condensing it into a separate small book which comes with the camera. They have also prepared an excellent video presentation explaining the use of the Zone System with the 205 TCC camera system. It is important to note that this is the first camera ever designed specifically to take full advantage of the control offered by the Zone System.

The last operational mode on the camera is the **M**, manual, mode. In all of the previous modes the shutter speed control ring, which is concentric with the rear of the lens on the front of the camera body, has been left set to **1** second and has had no function. When the camera is set to **M**, this ring becomes active and is used to set the shutter speed. By pressing the shutter release button to the first detent, the meter is activated and the shutter speed and aperture are displayed on the LCD panel. Releasing the button changes the display and indicates over- or under exposure in place of the aperture. The photographer then adjusts shutter speed, aperture or both to produce an **0** reading in this display, indicating perfect exposure. Meter display is continuous and will respond to very small changes in light value by indicating bars next to the **0** and a **+** or **-** in front. In the M mode, the **AE**-lock button may also be used to turn on the meter, but serves no other function, and the adjustment buttons are totally inactive.

Additional information is displayed in the viewfinder in all modes. To the right of the LCD panel is a triangular red LED which flashes to indicate settings which could result in exposure error. The mode selected is also displayed at all times. A low battery warning also will appear in plenty of time to allow the photographer to finish shooting and replace the battery. There are **Hi** and **Lo** warnings which will appear if the brightness range of the subject falls outside the metering range, a **Hi FLASH** and **Lo FLASH** warnings which appear in conjunction with an

SCA type compatible flash unit, as well as specific warnings in Zone and Differential modes when readings fall outside the limits. Additionally, the manual shutter speed control ring may be set to a specific speed and

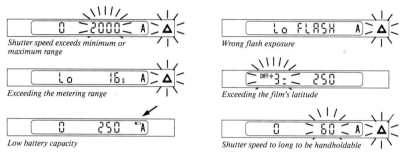

Shutter speed exceeds minimum or maximum range

Exceeding the metering range

Low battery capacity

Wrong flash exposure

Exceeding the film's latitude

Shutter speed to long to be handholdable

Warning signals that appear in the LCD panel in the viewfinder.

a warning will be triggered in the LCD panel when the camera selects a speed slower than that set. This can be set to the photographer's personal low limit for hand held photographs, but does not prevent the exposure from being made.

Most other operations of the camera will be easily familiar to any user of the Hasselblad system. The film is advanced by means of the right-side crank, which makes one full revolution to move the film one frame and re-cock the shutter. In the center of the crank is a button which releases the film advance for multiple exposures. Pressing a chromed catch on the crank and then turning the crank counter-clockwise allows it to be removed so that the optional motor drive may be fitted. Below the crank is the mirror pre-release lever which also doubles on this camera to activate the self-timer if pushed twice.

The top of the camera body accepts finders in the same manner as previous Hasselblad cameras. In fact, older finders will fit, but will make it impossible to see the LCD panel which is outside the image area. Focusing screens are retained by two clips as in other current Hasselblad cameras and are interchangeable. However, only the screens specifically made for the 205 TCC have the central circle indicating the metering area.

Except for the ISO and Zone Compensation dials on the left side, the TCC film magazine is identical to current non-TCC Hasselblad magazines, and is loaded in the same manner.

The Hasselblad 205TCC has been designed for the new TCC-series of lenses, but does not make older lenses in the F-, CF-, and C-series

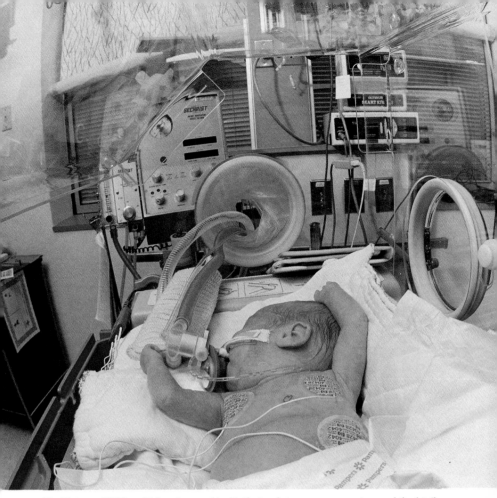

The Distagon CF 30mm Fisheye lens used inside the incubator was necessary to record the detail required. Photo: Chet Szymecki.

obsolete. Thus the only Hasselblad lenses which cannot be used on the 205TCC are those for the original Hasselblad 1600F and 1000F cameras. I used a 150mm CF lens on the 205TCC and found that the only inconvenience was that I had to stop the lens down manually to take a meter reading and I did not have an aperture readout in the viewfinder. That's a small tradeoff for being able to use an entire selection of existing lenses. Exposures made through the 150mm CF lens were just as accurate as those made with the TCC lenses I had. There is a very thorough appendix in the instruction manual covering the use of all older lenses on the camera.

In the past I had not been very happy holding Hasselblad cameras without a handgrip, but the TCC has a new rubberized grip surface on the lower part of the body and rubber support rails on the bottom, and is a much better fit in the hands. I was able to use their suggested hold, with my left hand under and supporting the camera, and my right hand on the motor drive grip. Also when using the hand crank, I used the same support, using my right hand for extra stability over top the prism. All of the controls for exposure are then easily manipulated with the thumb of the left hand, focusing is done with thumb and forefinger of the left hand, and the camera is fired with the forefinger or second finger of the same hand. It produces very smooth operation, and allows the location of the controls to be learned very rapidly.

Right: Children's portraiture is one of the most challenging of all types of photography. Robert Ruymen has taken the time to let this little girl be herself, and has produced a wonderful portrait in the process.

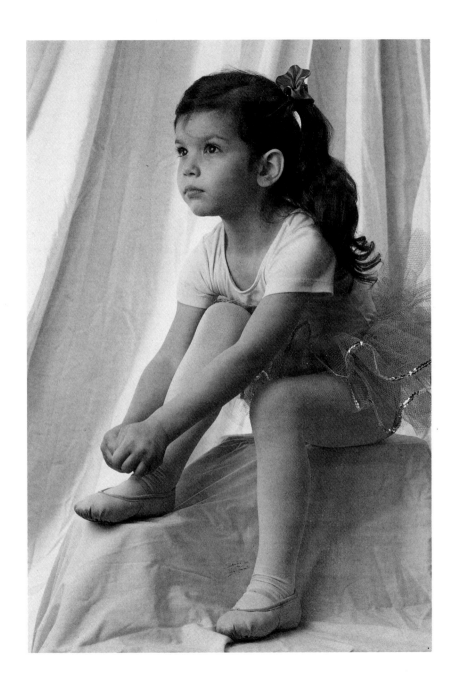

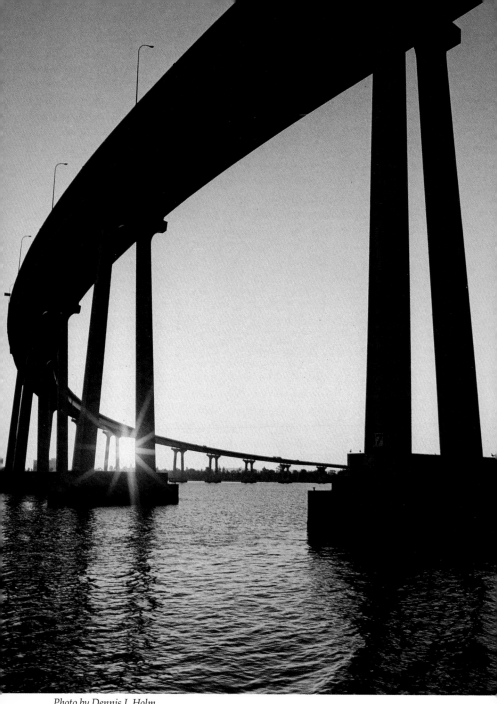

Photo by Dennis J. Holm.

4: Operation of the Cameras

The first hurdle to cross by the new Hasselblad user is learning to operate the cameras. Failure to follow the prescribed procedures in operation can lead to dissatisfaction with a camera which is performing correctly. I suggest practising all of the operational procedures prior to attempting picture taking with the camera.

The first procedure is learning about the 120 and 220 film magazines. Regardless of vintage, these film magazines have certain basic similarities and operate in a similar manner. The original magazines for 120 are referred to as Magazine 12. The later magazines which feature automatic

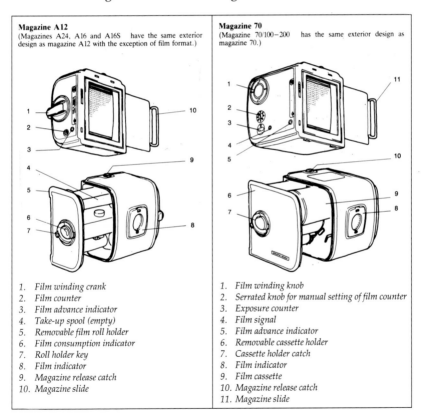

Magazine A12
(Magazines A24, A16 and A16S have the same exterior design as magazine A12 with the exception of film format.)

Magazine 70
(Magazine 70/100−200 has the same exterior design as magazine 70.)

1. Film winding crank
2. Film counter
3. Film advance indicator
4. Take-up spool (empty)
5. Removable film roll holder
6. Film consumption indicator
7. Roll holder key
8. Film indicator
9. Magazine release catch
10. Magazine slide

1. Film winding knob
2. Serrated knob for manual setting of film counter
3. Exposure counter
4. Film signal
5. Film advance indicator
6. Removable cassette holder
7. Cassette holder catch
8. Film indicator
9. Film cassette
10. Magazine release catch
11. Magazine slide

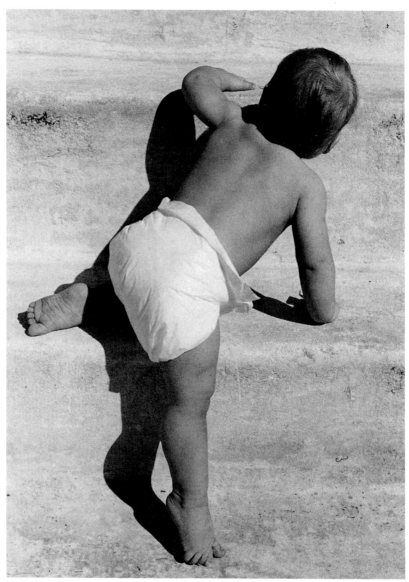

"Baby Steps" by Totsie Mavine, 80mm lens.

advance to the first frame are referred to as Magazine A 12 for 120 and A 24 for 220. Additionally, there are magazines for the 645 format, which produce 16 and 32 exposures with 120 and 220 film, these are referred to as Magazines A 16 and A 32. There is also a magazine called Magazine A16S for producing superslides in the 41 x 41 mm format, and a special A/12V which produces 12 645 format vertical images on 120 film. Loading all these 120/220 magazines is basically the same.

Some photographers prefer to load the magazine after removing it from the camera body, but this is not necessary. If you find that it is easier for you to load the magazine once detatched, then by all means do so. There are no rights and wrongs here, just choices for personal preference. The magazine may only be removed from the camera body with the dark slide in place and pushed fully home. With the dark slide in place, the button on top of the magazine is pushed to the

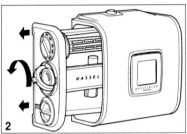

right and the magazine comes free at the top and swings down and away from the body. The dark slide has a rolled outer end which attaches to the handle, and can be put into the slot in the magazine either of two ways. However, if you intend to load the magazine with the dark slide in place, the dark slide must be inserted properly, which is with the rolled outer section toward the front of the camera. If it is put in the other way round, the magazine insert will not come free.

Whether mounted on the camera or not, the magazine is loaded by removing the film insert. This is done by unfolding the key on the left side and giving it a quarter turn in a counter-clockwise direction. The film insert may then be withdrawn from the magazine toward the left.

The film is loaded into the insert with the full roll on the bottom and the empty spool on the top. To move the empty spool, the retaining arm on the right end must be either folded outward (on all older magazines) or simply lifted outward with the end of the spool (on current magazines). The spool is fitted into the upper chamber of the film insert on older magazines by folding the retaining arm outward, putting the spool

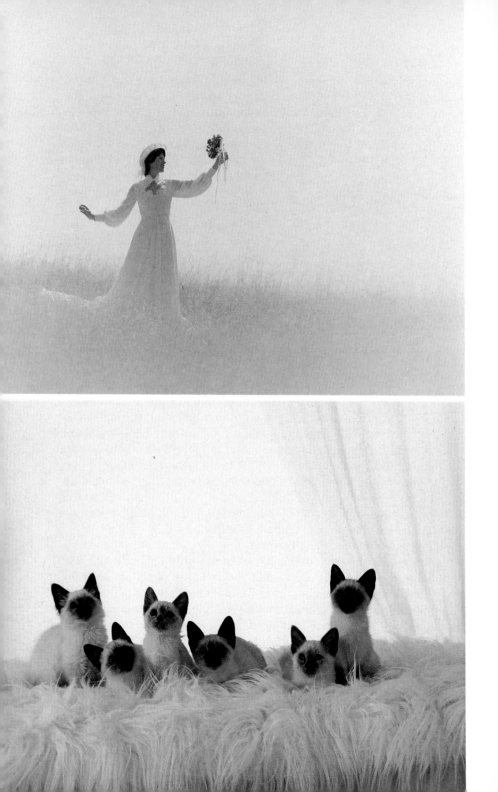

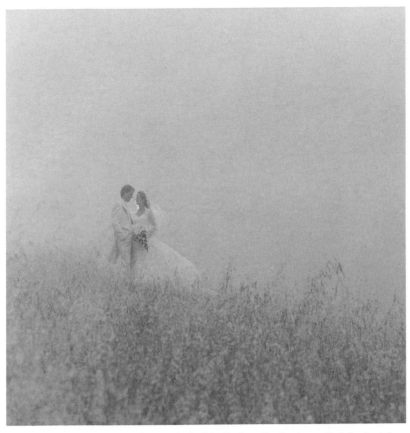

Above: Approaches to wedding photography by John Paulson. For the shot on the left a frosted vignetter was used for the bottom part of the picture. The bride was backlit by the sun and a fill-flash was placed just over the camera. For the couple on the right it was a very foggy day. Backlighting was by a radio slave-controlled flash.

Left below: Getting a single kitten to cooperate can be a real task. To photograph this entire litter, photographer Ilija Galic needed both patience and a lot of good luck.

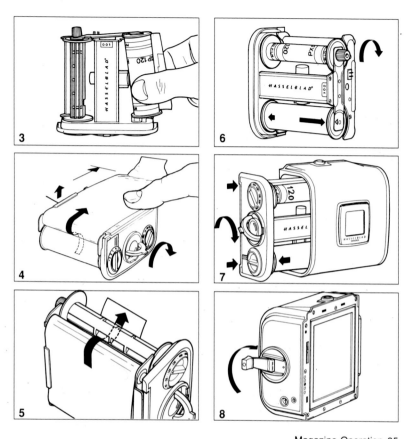

in place, and folding the arm back again, making sure that the key on the spool retainer fits into the slot on the spool. The spool is fitted into the upper chamber of the film insert on current magazines by placing the right end against the spool retainer and pushing outward against spring tension while seating the left end of the spool. Inserting the full roll of film into the bottom chamber of the film insert is done in the same manner. The tongue of the film backing paper is then pulled down around the bottom roller and across the film pressure plate. On the right end of the film pressure plate is a chromed clip which must be atop the film backing paper. This clip is relaxed by turning the key on the film insert (the same key used to remove the insert from the magazine) clockwise a quarter turn. The film backing paper is then slipped under this chromed clip and brought over the upper roller and into the slot in the takeup spool. The

46

black side of the backing paper must be facing forward at this stage, if the colored side is visible on the pressure plate the film has been loaded backwards and will not be exposed. The take-up spool is turned by hand to make sure that the film tongue is properly attached and that the film backing paper is centered onto the spool. The backing paper must not be wound onto the spool off center, as this will cause film winding problems and possibly lead to fogged film edges.

Once this had been done, the film backing paper is advanced by finger pressure until the start mark (double arrows) on the backing paper aligns with the start mark on the lower film spool retaining arm. On older magazines without this start mark on the retaining arms, follow the special procedure outlined below. On magazines with the start marks, once the film start marks and film insert start marks have been aligned, the insert key is once more turned counter-clockwise a quarter turn to tighten the chromed clip, and the insert is replaced in the magazine and pressed into place. Making sure that the insert is fully seated in the magazine, lock it into place by turning the key back clockwise a quarter turn and fold the key into place. Using the knob or crank on the right side of the magazine, wind it until it stops, which brings frame one into place.

On older magazines without film start marks on the insert, the insert is placed back into the magazine as above and locked into place. Then the film winding key on the right side is unfolded and turned until it stops in a counter-clockwise direction. This sets the frame counter to 1. Then the same key is used in the opposite direction to advance the film, after opening the door in the back of the magazine, until the number 1 on the film backing paper is seen centered at the bottom of the viewing tube. Because this is a direct view of the back of the film, it is very important only to perform this operation well shaded from the sun outdoors or in dim light indoors, and extreme care must be exercised with faster films. My own advice would be not to use these older magazines with really fast films, but I know photographers who claim perfect success in this venture, so if you must use such magazines be certain to make tests prior to trusting them for important jobs.

If you are planning to load several magazines and then store them for some time prior to use, it is a good idea not to advance the film to the first frame. The reason for this is that the strong reverse curl induced in the film by the design of the magazine may cause the following frame to buckle up away from the pressure plate somewhat if left long enough for the film to "take" this curl. This may cause the second frame to be out of

focus. Similarly, it is not a good idea to store magazines for long periods of time midway through the roll. If you must do this, consider the second exposure after such storage may not be as sharp as the first or succeeding exposures. Of course, when using professional films it is never a good idea to store them for prolonged periods anyway, and the latent image on any film deteriorates after the exposure. See Chapter 11 for more information about storage.

Because in normal operation the Hasselblad camera bodies always advance the film when wound, it is important to have the camera body cocked when attaching a newly loaded magazine to avoid wasting the first frame. In the 1000- and 500-series cameras, this is easily determined by checking the small round window on the right front of the film magazine and the similar window on the camera body. The film magazine window shows white when the film has been advanced, red when it has not, while the camera body shows white when cocked, red when not. The simplest rule of thumb is only to attach like colors to avoid wasting frames of film or having accidental double exposures. All Hasselblad bodies with the exception of the 2003FCW and 205TCC have this indicator window. On those cameras it is possible to determine if the camera is cocked only by attempting to wind.

Attaching the Lens
Check that both the camera and the lens are cocked. The illustration shows the proper position of the drive shaft against the index marks for the camera drive shaft (top) and the lens drive shaft (bottom).

Users of 35mm cameras who move up to medium format often get into trouble with Hasselblads for not following some important basic procedures which will, at first, seem unfamiliar. Removing and refitting lenses, for example, is not simply a matter of taking the lens off and putting it back. Hasselblad cameras are designed for lens changing only when the camera body <u>and</u> the lens are cocked.

Hasselblad lenses are removed by pressing a button on the lower right front of the camera body (as seen facing the camera) and then turning the

lens about a quarter turn in a counter-clockwise direction. However, if the camera and lens have not been cocked, the lens will not turn easily and attempting to remove it by force can damage the body or lens, or both. If you attempt to remove a lens and encounter resistance, stop immediately and check to make certain that the camera is cocked.

Mechanical connection between body and lens is a rotary link, with a slotted shaft on the lens and a key on the body, which must fit together correctly for proper operation. Before attempting to attach a lens to a body, always make certain, again that both are cocked. On the camera body this is simply a matter of checking the indicator window on the side of the body or attempting to wind it.

To see if a lens is cocked, remove the rear lens cap and look at the lens from the rear. You will see the end of a slotted shaft at the bottom of the lens rear face, with an arrow part way round it and a red dot. One end of the slot in the shaft should be aligned with this red dot when the lens is cocked. When the shutter is fired the slotted shaft rotates and comes to rest with the end of the slot above the red dot. If a lens is accidentally tripped while off the camera (which can happen if the small lever visible through an opening to the right of the slotted shaft is pressed), it can be re-cocked simply by carefully turning the slotted shaft in the direction of the arrow (clockwise) until it stops and is once more aligned with the red dot. In most countries this can be done with a coin, if the coin is too thick a small screwdriver may be used.

If any part of the camera system refuses to mate smoothly and precisely with any other, never use force. These cameras and accessories are very precisely made instruments, and small parts may be easily bent by force, creating expensive repair bills.

Sometimes a 500-series camera will jam. This happens with any camera system, but with the Hasselblad it is usually quite easy to remedy. This applies only to manually advanced 500-series cameras, not the motorized ones. If the camera is stuck, will not advance or fire, the first thing to do is to remove the film magazine. With the magazine removed, try again to see if the camera is free; sometimes a magazine will jam if the film is loaded incorrectly.

If the camera body is still jammed, gently press the lower door of the secondary shutter open, you will not harm it by doing this if you are gentle. Looking down inside the camera you should see the rear of the lens mount, and below that a chromed screw head. Using a long, narrow screwdriver, engage this screw and gently turn in a clockwise direction.

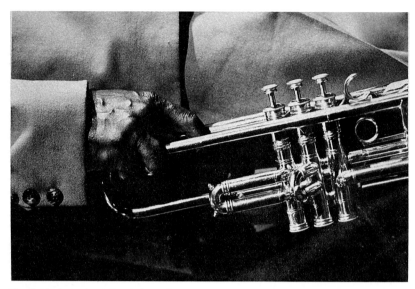

Top: Louis Armstrong's hand. *Right: George Lewis.*
George Fletcher has been engaged in a long project to document the living legends of jazz. He has
photographed most of these great musicians in a simple, direct style with the Hasselblad camera.

This is a secondary way to re-cock the camera body and lens, since jams are usually caused by the camera not fully going through its release cycle. If the screw does not turn with gentle pressure, do no more and take it to a repairman. However, in most cases the screw will turn to a definite stop and the camera can then be fired.

This is to be considered an emergency procedure only, if you have the time you should always take the camera in for repair, and if it jams again you should definitely have it looked at. Probably it needs only a cleaning and lubrication, since the mechanisms of Hasselblad cameras are very rugged.

From its inception the Hasselblad system has been designed to feature interchangeable viewfinders. The standard folding hood may be interchanged with a number of optional finders. To change from one finder to another, simply first remove the magazine back from the camera as described at the beginning of this chapter. Once the magazine is removed from the body, the viewfinder may be easily removed by simply sliding straight backward. When doing this exercise great care not to touch the

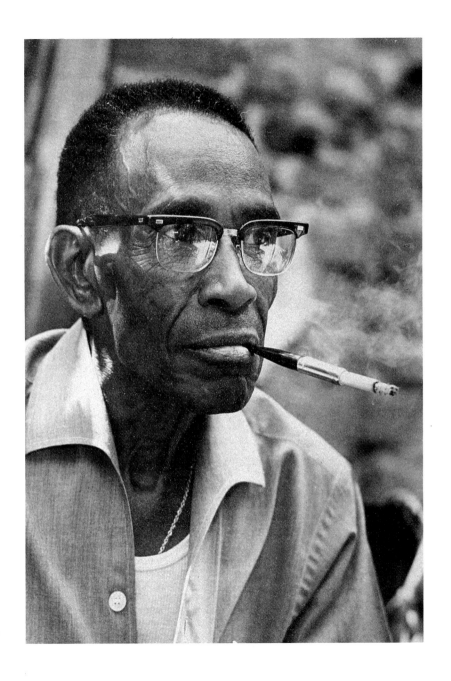

exposed shutter curtains or secondary blinds. The replacement view-finder is simply slid home until it stops and retained in place by the magazine when that is refitted.

When using one of the prism finders with built-in metering, make certain that the prism finder is properly matched to the type of focusing screen installed in the camera. Since these meters read light directly from

Above: Reflex viewfinder RM
For photography at eyelevel with a sighting angle that is parallel to that of the lens. Yields an unreversed focusing screen image and magnifies it three times. The ocular is focusable from +5 to -5 diopters for compensation of faulty vision. The ocular is fitted with a rotatable rubber eyepiece.

1. Battery compartment
2. Battery
3. On/off switch
* 4. Accessory shoe
5. Scale for lens aperture
6. Scale for film sensitivity
7. Film sensitivity selector
8. Lens control selector
 (Selector for maximum aperture)
* 9. Position for correction lens
* 10. Rubber eyepiece
11. Battery test signal
12. Illuminated exposure value scale

* *Features in addition to the optical system and exterior design that are the same on viewfinders PME3 and PM.*

Left: The Meter prism finder PME3 and Prism viewfinder PM
Prism viewfinders for eyelevel photography with a 45° sighting angle. Yields an unreversed focusing screen image that is magnified three times. Can be fitted with correction lenses for compensation of faulty vision. The ocular is equipped with a rotatable rubber eyepiece.
The Meter prism finder also features TTL centre-weighted metering.

Standard focusing hood
An all-round viewfinder for photography with the camera at a distance or right up against the eye. Sighting angle perpendicular to the lens. Its design makes camera work at hip level or difficult angles possible.
·The focusing hood is collapsible and can be raised or lowered while attached to the camera. Provides effective screening of the focusing screen image. A folding fine-focus magnifier enlarges the image 2 1/2 times. The collapsed hood takes a minimum amount of space, making the entire camera compact.

Magnifying hood
For carefully checking the focus and composition of the focusing screen image. Sighting angle perpendicular to the lens. Enlarges the focusing screen image 2 1/2 times. The ocular is adjustable from +3.5 to -2.5 diopters for compensation of faulty vision.

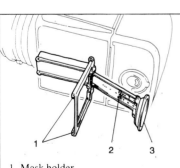

1. Mask holder
2. Parallax adjustment
3. Rubber eyepiece

Sports viewfinder
For direct viewfinding of fast moving camera subjects. Attaches to the accessory rail on the camera's left side (500-series only). Comprised of a frame with a position for interchangeable masks. Features parallax compensation through a movable sight with a rubber eyepiece. The fixed frame outlines the image field for 80mm focal length lenses when a film magazine for the 2 1/4 x 2 1/4 format is used. There are nine different interchangeable masks for lenses with greater focal lengths. The sports viewfinder is collapsible.

Frame viewfinder
For direct viewfinding of fas moving camera
subjects. Attaches to a square lens shade or
with the help of the frame viewfinder
attachment to the longer telephoto lenses.
Two square frames, of which the inner is
removable, outline an image field for 150mm,
250mm, 350mm and 500mm focal lengths
when magazines for the 2 1/4 x 2 1/4 format
are used. The frame viewfinder has a sight
that consists of double, diagonal crosses that
are aligned in unison.

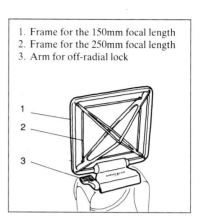

the screen, an improper match will lead to incorrect meter readings. The original CdS and PME 1 & 2 metering prism finders were designed to take meter readings off the original standard focusing screens. When the Acute Matte screen was introduced, because it is about twice as bright as the earlier screens, a new metering prism, the PME 3 was introduced to compensate automatically for this change. When using older metering prisms with the Acute Matte screen, it is necessary to set the ISO value to half its number to compensate for the increase in brightness.

Changing focusing screens may change the readings from your metering prism. If you are getting accurate exposure with one screen and want to switch to another, take a reading first through the screen which gives accurate readings, and then without moving the camera, switch screens and take a second reading through the new screen. If it differs, repeat the process several times and establish a correction factor for the new screen. Then you must always remember to set that correction factor when using that screen.

To change focusing screens remove the viewfinder as described above. If the camera is one of the models featuring user interchangeable screens, two chrome clips and two triangular cutouts will be seen, one on either side of the focusing screen. Using a fingernail or small tool, these clips are pressed to the side into the triangular cutouts to free the focusing screen. The camera is then inverted over the hand and the focusing screen will come free and drop out of the camera. Occasionally a screen will stick and refuse to come free in this manner. If this happens, do not bang the camera trying to shake the screen free. Instead, simply remove the lens from the camera, cover your finger with a clean handkerchief,

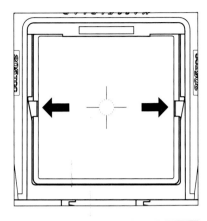

Removing the focusing screen

and reach in through the lens mount and gently press upward on the screen with the handkerchief-covered fingertip. This should easily free a stuck screen. If the screen does not come free with this gentle action, do not attempt any greater force, for something is definitely wrong, and the intervention of a repairman is indicated.

Once the screen has been removed, the new screen is simply dropped into place, taking care to make certain that it is put in right side up. The top of the frame is rounded and smooth, while the bottom of the frame has an extended flange at four corners and is crimped in the central areas on all four sides. Fitting a screen incorrectly will result in incorrect focus. A quick check after fitting a new screen is to set the lens to infinity and look through the camera at a distant object. If it appears to be sharp, the screen is in place correctly.

When changing screens in the 205TCC it is important not to damage the LCD panel which projects over the screen frame at the front of the camera. Be certain to slide the new screen under this LCD panel and its frame during installation.

Once the screen is installed there is no need to re-set the retaining clips. They automatically extend into place when the viewfinder is replaced.

The 2000FCW and 205TCC cameras accept a motor drive in place of their manual film advance cranks. To remove the crank, press the chrome catch on its rim toward the rear and turn the crank counter-clockwise until it comes free. To attach the motor, line up the arrow on its top surface with the red dot above the crank hub on the body and press into place, rotating clockwise to lock. A definite "click" will annnounce that it is locked into place. Once the motor is locked into place it will

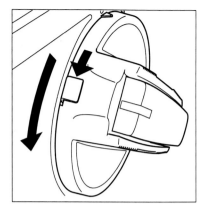

automatically cock the camera and advance the film after each exposure. Because the motor covers the crank hub and its double-exposure button, it is impossible to make double exposures with the motor mounted.

5: Hasselblad Lenses

From the inception of the system, Hasselblad has insisted on providing only the very best lenses for their system. While the original 1600F and 1000F used some lenses from Kodak, all lenses for the 500C and later cameras have come from the top German lens makers of Zeiss and Schneider.

Zeiss lenses have a well deserved reputation for being the best available. In totally objective lens tests, this superior quality has been verified, and many photographers consider Zeiss lenses as the only ones worthy of consideration in medium format photography.

Because Zeiss lenses use names as well as focal length and aperture designations, it may be helpful to have an understanding of what those names signify.

Distagon: so named because they increase apparent subject distance. These are all reverse-telephoto or retrofocus designs. Since the Hasselblad reflex cameras have a 74.9mm distance between lens flange and film, lenses shorter in focal length than about 80mm must be designed as retrofocus to clear the swinging reflex mirror. These lenses feature complex optical designs with multiple elements, as many as eleven being required to provide the necessary corner to corner sharpness and correction. Because of the number of elements, and the critical alignment necessary, these are expensive lenses to manufacture. Distagons are optimized for best performance at infinity, with good performance at closer distances. Some of them now feature "floating elements", a design in which some of the elements move differentially during focus, which provides maximum optical correction at any focusing distance.

Biogon: this is a true wide-angle lens, the only one in the Hasselblad system. Unfortunately, the rear of this lens must be very close to the film, so it is not usable on a reflex camera. It is made for the special Superwide body. However, it offers greater correction than is possible with even the best retrofocus design. The Biogon is an eight-element near-symmetrical design.

Planar: so named for their very flat field of focus. These are symmetrical or near-symmetrical designs with five to seven elements. In addition to field flatness, Planar designs are noted for excellent overall sharpness,

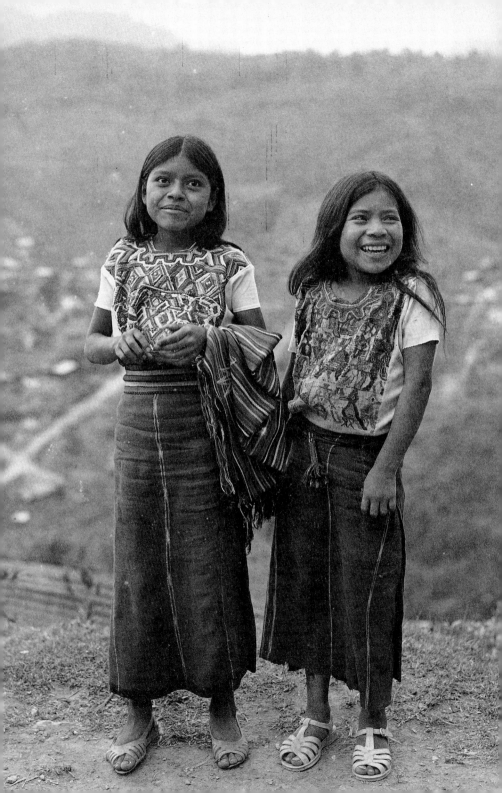

even out to the corners of the image field. Ordinarily, Planars are optimized for infinity performance, and do quite well at close ranges as well. The special S-Planar lenses are designed as macro lenses, that is they are corrected for close subject distances instead of infinity. However, my own work with the 120mm S-Planar indicates that it produces exceptionally sharp images throughout its focusing range.

Sonnar: from the German word for Sun. These lenses were originally designed for high speed and even illumination. They have from four to seven elements, with the main components in front of the diaphragm. Because they function as telephotos, they are extremely small relative to their focal length.

Tele-Tessar: these lenses are typical telephoto designs, with large positive front components, small negative rear components, and a long air space in between. Tessar means "four" and these lenses typically have four or five elements. The Tele-Apotessar is a similar type of lens, but with superior optical correction for true apochromatic performance; that is it focuses all colors of visible light at the same plane to eliminate color fringing.

Variogon: this is Schneider's name for a lens with a variable focal length, a zoom.

Mutar: this is a Zeiss trade name which refers to a supplementary attachment which changes, or mutates, the focal length of the lens it is attached to. In the Hasselblad system, the Mutar is a 2X tele converter.

*From **Images of Peru** by Dennis Ryan Kelly, Jr.*
Wide apertures and long focal lengths can isolate the subject from a messy background.

COATING ON HASSELBLAD LENSES

Lens coating is intended to reduce the amount of light which is reflected back from the surface of the lens elements at the air/glass interface. All lens elements reflect a certain portion of the light which strikes them and transmit the rest. In the early days of lens design this reflectance, which can be about 5% of the light, was unimportant from a transmission point of view because lenses did not have a large number of elements.

However, with today's zoom and wide angle lenses having up to 20 elements, a loss of 5% at each air/glass interface would produce an unacceptably large light loss through the lens as a whole. The first solution to this problem, developed in the 1940's, was to apply a very thin coating of magnesium fluoride to the lens surfaces. It had been discovered that such a coating reduced reflection, and manufacturers were quick to adopt this coating and begin research to refine and improve it.

Zeiss began marking its lenses which were coated with a red **T** shortly after WW II to distinguish them from the pre-war, uncoated versions. All Hasselblad lenses have been coated, from 1957 onward, to improve performance.

However, even with the improvement of lens coating, optical engineers were not satisfied. Lens surfaces still tended to reflect light, and loss of transmission and high levels of flare or veiling glare were still a problem with multi element designs. To combat this problem, multi-layer coatings were developed, with each layer of the coating acting on particular wavelengths of light. The exact makeup of these coatings and the number of layers are often proprietary secrets of the manufacturers, but I have been told that some lens elements in certain lenses have as many as seventeen distinct layers of coating.

Such multi-layer lens coating has come to be called multicoating. All Zeiss multicoated lenses are so identified by the **T*** symbol, the name Zeiss uses for their multicoating process (pronounced T-Star). Since the Variogon is made by Schneider rather than Zeiss it does not carry the **T*** designation, but is, in fact, multicoated.

Older Hasselblad lenses, without the **T*** designation, can still be excellent performers, particularly when used with the proper lens hood to prevent stray light and the reflections it can cause. However, the **T*** lenses can often be used in high-flare situations, such as shooting directly into the sun, without producing excessive levels of flare.

SPECIAL PURPOSE LENSES

There may be times when the photographer needs to use a particular lens which is not offered in the Hasselblad system. For special applications such as this the lens mount adapter is available. It has a Hasselblad bayonet mount on its rear surface and blank metal on the front. A precision machinist can drill and thread this adapter to accept many kinds of lenses, from view camera lenses to special microscope objectives, to ultra-long telephoto lenses. The well-known American commercial photographer Al Satterwhite has had a series of long Nikon telephoto lenses adapted to his 2000-series Hasselblad cameras and has produced some spectacular images with them. While many lenses designed for 35mm work will not adequately cover the image are of the Hasselblad, most telephoto lenses project a much larger image circle than necessary for 35mm and can produce excellent results.

In my own case, I frequently shoot with a 180mm,f/2.8 Carl Zeiss Jena Olympia-Sonnar which was originally made for 35mm use, but which I had adapted to 2 1/4 square, and the results have been excellent. Of course, this sort of adapted lens is unlikely to have its own shutter, and is not easily used on the 500-series cameras. Some view camera lenses with shutters can be synchronized to the 500 bodies with a double cable release, and some lenses can be mounted into the Hasselblad microscope shutter for fully synchronized operation.

For those who want or need such custom adaptation, there are shops in most countries who specialize in making such modifications. Keep in mind, however, that such work is expensive.

Some photographers would like to use their Hasselblad taking lenses on their enlarger. They reason that the lens which produced the negative in the first place would be best matched to reproduce it as a print. In practice, this can work out rather well. Hasselblad sells a lens flange which is fitted on the front with the Hasselblad bayonet, just like the camera body, and is blank on the other side. A machinist can attach a threaded tube for your enlarger, or the flange may be permanently mounted onto a lensboard for the enlarger. While this may be acceptable in many cases, I have not personally found that camera lenses work as well as specially designed enlarging lenses, particularly at the wider apertures. If you use your Hasselblad lenses on an enlarger, stop them down to the middle aperture range for maximum sharpness.

CF LENSES

All lenses are fitted with a Prontor CF shutter and are in a focusing mount with bayonet coupling for the automatic diaphragm.

Distagon CF 30mm,f/3.5

With its angular field of 180° across the image field diagonal, this fisheye lens covers the entire 6x6 cm format.

Owing to the extremely large angular field photographs taken with this lens supply ample information even of narrow interiors. Its outstanding

image quality offers the creative photographer new possibilities. The excellent correction of this lens results in outstanding sharpness, even at maximum aperture.

Four special filters (neutral glass and three color filters) are supplied with each lens. These filters are used internally, because even the largest attachment filter would occlude the 180° angular field. The filter is part of the optical system. Either the neutral glass or one of the color filters must always be mounted in the lens. To exchange filters, the front of the lens is removed, and the filter screwed into the rear of its mount.

Specification:

Elements	8
Groups	7
Focal length	30.6mm
Angular field	diagonal 180°, side 112°
Aperture range	3.5-22
Filter connection	thread M 24x0.5mm, replaceable by loosening of front component
Closest focusing distance	0.3m
Weight	approx 1365g
Length	117.5mm

For the perspective wanted in this photo, only the 60mm lens was exactly right. It is a moderate wide angle, one which many photographers find works well as their "normal" lens. (Photo by J. Michael Salema).

Biogon CF 38mm,f/4.5
(for 903SWC only)

Because of the extremely short distance of the last lens vertex from the film plane (back focal distance), the Biogon lens cannot be used in the

Hasselblad 500 C/M, 503 CX, 553 ELX and 2003 FCW. It is therefore assembled in its own special camera body, the Superwide C.

Even at full aperture the 38mm Biogan f/4.5 lens produces pictures of outstanding sharpness and brilliance. Distortion aberration is virtually eliminated. Owing to the short focal length, there is such a large depth of field that the fixed-focus adjustment can frequently be used. It is particularly suitable for architectural and model photography, for interiors and for the recording of technical processes at close range.

Specification:

Elements	8
Groups	5
Focal length	38.4mm
Angular field	diagonal 90°, side 72°
Aperture range	4.5-22
Filter connection	bayonet for Hasselblad series 60
Closest focusing distance	0.3m

Distagon CF 40mm,f/4

This new 40mm lens is lighter and smaller than its predecessor but has superior optical performance. It has two focusing rings. While the one nearest the camera body can be continuously adjusted as usual and has a complete scale from infinity to 0.5m, the focusing ring on the front mount is provided with the three click stops, infinity - 2m, 2m - 0.9m and 0.9m - 0-5m. When setting this ring, the spacing between the front group

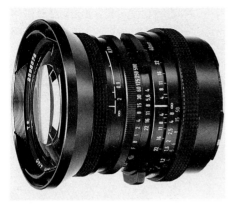

(elements 1 and 2) and the rest of the system is changed. In this way it is possible to select the air space affording the best image quality for any of these ranges. After this, focusing proper must be carried out as usual.

Specification:

Elements	11
Groups	10
Focal length	40.9mm
Angular field	diagonal 88.7°, side 69.3°
Aperture range	4-22
Filter connection	Hasselblad series 93
Closest focusing distance	0.5m. Additional setting of the focusing ring on the front mount in 3 click stops
Smallest object field	473x473mm
Weight	approx 915g
Length	101.5mm

Distagon CF 50mm, f/4

This new 50mm Distagon f/4 lens is lighter and more compact than its predecessor - despite the addition of further lens elements. Image quality has been improved not only in the distance range; the use of a floating element has also resulted in a considerable improvement in the near range.

Two focusing rings are fea-

tured on the 50mm Distagon f/4 lens. The first, which is marked with 4 distance ranges, is used to preselect the range required for the photograph. The following ranges are available: infinity - 4m, 4 - 1.2m, 1.2m - 0.8m and 0.8 and 0.5m. Ajustment of this ring changes the distance of the front group (elements 1 - 4) from the rest of the optical system, providing the most favourable spacing for optimum image quality. The second ring, adjustable from infinity to 0.5m, is then used to focus in the usual way.

This lens is ideal for landscape, architectural and journalistic photography.

Specification:

Elements	9
Groups	8
Focal length	52.0mm
Angular field	diagonal 75°, side 58°
Aperture range	4-32
Filter connection	bayonet for Hasselblad series 60
Closest focusing distance	0.5m
Weight	approx 800g
Length	95.1mm

Distagon CF 60mm,f/3.5

This wide-angle lens surpasses its predecessor, the 60mm Distagon f/4 lens, in performance and speed. Special features are its compact design and its relatively low weight. Its wide range of applications make it almost a universal lens.

Specification:

Elements	7
Groups	7
Focal length	60.2mm
Angular field	diagonal 66°, side 50°
Aperture range	3.5-22
Filter connection	bayonet for Hasselblad series 60
Closest focusing distance	0.6m
Weight	approx 680g
Length	82.8mm

Planar CF 80mm,f/2.8

This lens is characterized by an extremely uniform edge-to-edge sharpness at full aperture, owing to the excellent correction of all lens aberrations. As indicated by its name, the astigmatic flatness of the image field is outstanding.

The focal length corresponds approximately to the diagonal of the 6x6cm format. The lens is suited for almost any task in general photography.

Specification:

Elements	7
Groups	5
Focal length	80.5mm
Angular field	diagonal 52°, side 38°
Aperture range	2.8-22
Filter connection	bayonet for Hasselblad series 60
Closest focusing distance	0.9m
Weight	approx 510g
Length	65mm

Planar CF 100mm, f/3.5

The 100mm Planar f/3.5 lens produces outstanding image quality and freedom from distortion. At full aperture and when stopped down

moderately, the image quality of the 100mm Planar f/3.5 lens is superior to that of the 80mm Planar lens. For this reason the lens is recommended as a standard lens for photography where the demands for detail recognition and brilliance are high. The excellent distortion correction is also of great importance for architectural photography and for all applications which require an exact reproduction of the geometry of the object (e.g. for surveying).

Specification:

Elements	5
Groups	4
Focal length	100.3mm
Angular field	diagonal 43°, side 32°
Aperture range	3.5-22
Filter connection	bayonet for Hasselblad series 60
Closest focusing distance	0.9m
Weight	approx 605g
Length	75mm

UV-Sonnar CF 105mm, f/4.3

The 105mm UV-Sonnar f/4.3 is a special design consisting of fluorite and quartz lens elements with excellent light transmission in the UV spectral range and chromatic correction in the UV as well as the visible spectral range. The lens is thus ideal for photography in the UV and in the visible ranges. Over the wide range from far UV up to

the visible spectral range, the UV-Sonnar lens features high performance and excellent distortion correction. For UV photographs, focusing can be made with visible light without any further adjustment.

The lens finds wide application in technical and scientific photography including studies of textiles, printing forgeries, and materials of all kinds. It is of special interest for extraterrestrial UV photography.

Specification:

Elements	7
Groups	7
Focal length	107.5mm
Angular field	diagonal 40°, side 29°
Spectral range	215-700nm
Aperture range	4.3-32
Filter connection	bayonet for Hasselblad series 60
Closest focusing distance	1.8m
Weight	approx 820g
Length	90.6mm

Makro-Planar CF 120mm,f/4

The main field of application of this lens is close-up photography and it performs best in the region of slightly reduced imaging of the subject. The shortest taking distance of 0.8m (reproduction ratio of 1:4.5) can be set

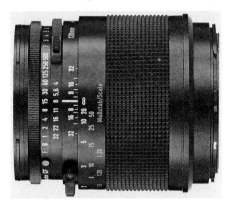

using the helical focusing mount. By inserting the Hasselblad extension tube 32 the macro range can be increased to 1:2.

Macro pictures are usually taken at small working apertures to increase the depth of field. At first glance the wider maximum aperture therefore seems unnecessary, but the considerable increase in extension when taking close-ups results in a marked reduction of the effective lens speed and hence in ground-glass brightness, so the large maximum aperture assists focusing.

Specification:

Elements	6
Groups	4
Focal length	120.9mm
Angular field	diagonal 36.6°, side 26°
Aperture range	4-32
Filter connection	bayonet for Hasselblad series 60
Closest focusing distance	0.8m
Weight	approx 695g
Length	99mm

Makro-Planar CF 135mm,f/5.6

The 135mm Makro-Planar f/5.6 lens is designed for use with a bellows extension, so it has no helical focusing mount.

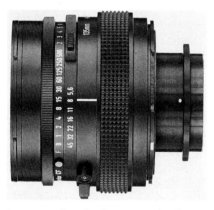

With the bellows extension, the focusing range of the lens is continuous from infinity to scale 1:1. Like the 120mm Makro-Planar lens the 135mm Makro-Planar f/5.6 lens is optimally corrected for close-range work and is therefore ideally suited for all subjects at close range where maximum image quality and freedom from distortion are required.

Owing to its relatively constant correction over a wide range of image scales the lens can also be used successfully for distance shots if it is stopped down slightly more than a normal lens.

Specification:

Elements	7
Groups	5
Focal length	137.1mm
Angular field	diagonal 32°, side 23°
Aperture range	5.6-45
Filter connection	bayonet for Hasselblad series 60
Closest focusing distance	0.54m (image scale 1:1)

Sonnar CF 150mm,f/4

Many photographers consider the 150mm Sonnar f/4 lens the most important second lens for the Hasselblad camera. Even at full aperture 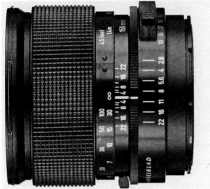 the lens covers the entire 6x6cm format and produces pictures of excellent sharpness and brilliance. The compact design offers excellent corner-to-corner illumination of the image field. It is ideally suited for portraiture, press, sports, and stage photography. Owing to its high speed, this lens allows short exposure times and thus hand-held shots even under unfavorable light conditions, e.g. for stage photography or documentary series in bad weather.

Specification:

Elements	5
Groups	3
Focal length	151.2mm
Angular field	diagonal 29°, side 21°
Aperture range	4-32
Filter connection	bayonet for Hasselblad series 60
Closest focusing distance	1.4m
Weight	approx 785g
Length	100.1mm

Sonnar CF 180mm,f/4

This new lens fills what had been a wide gap in the Hasselblad range of lenses between 150mm and 250mm. It will be particularly welcomed by portrait photographers. The overall quality of reproduction is extraordinarily good, with an exceptionally high degree of sharpness. The large distance between the rear lens surface and the film plane ensures that light fall-off at the corners of the image is very small. With the Mutar 2x converter you get a 360mm lens of very high reproduction quality. Portrait photographers will probably need to soften the sharpness in many situations by adding one or more Softar filters.

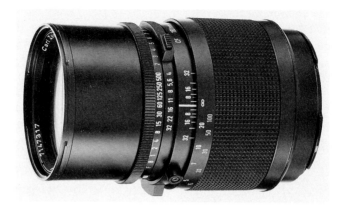

Specification:

Elements	5
Focal length	180mm
Angular field	diagonal 24.5°, side 17.5°
Filter connection	bayonet for Hasselblad series 60
Closest focusing distance	1.55m
Weight	1050g
Length	125mm

Sonnar CF 250mm,f/5.6
Even at full aperture the image quality of this lens is excellent and cannot be improved any further by stopping down. Despite its long focal length

and the remarkable tele effect, the lens is compact and handy and allows hand-held exposure.

Applications: portraiture, long-range, press, sports, and stage photography. For outdoor portraiture the narrow depth-of-field range of the lens can be applied to advantage to separate the model from a distracting background.

Specification:

Elements	4
Groups	3
Focal length	248.4mm
Angular field	diagonal 18°, side 13°
Aperture range	5.6-45
Filter connection	bayonet for Hasselblad series 60
Closest focusing distance	2.5m
Weight	approx 1000g
Length	163.6mm

Sonnar Superachromat CF 250mm,f/5.6

With this lens the secondary spectrum, which is the dominating aberration of lenses of long focal length, is corrected for the entire spectral range between approx 400 and 1000nm.

Visual focusing in visible light guarantees optimum sharpness, even on IR or false-color-film.

It is ideal for taking photographs which are to be considerably enlarged and is primarily applied in technical and scientific IR photography. Special effects in landscape and architectural photography, geology, hydrology and archaeological documentation with the aid of aerial photographs, botany, plant pathology, environmental control and multi-spectral photography are examples of the wide range of applications of this extraordinary lens.

As the focusing ring has no infinity stop position, focusing for long range work must be carried out with the aid of the camera focusing screen.

Specification:

Elements	6
Groups	6
Focal length	249.6mm
Angular field	diagonal 18°, side 13°
Aperture range	5.6-45
Filter connection	bayonet for Hasselblad series 60
Closest focusing distance	approx 2.8m
Weight	approx 985g
Length	157.7mm

Tele-Tessar CF 350mm, f/5.6
With a length of only 22.5cm this tele lens is compact and handy in spite of its long focal length. Even at full aperture the image quality is excellent for a lens of so long a focal length.

The 350mm Tele-Tessar f/5.6 lens is well suited for long-range and animal photography and for picture series. Like all lenses with long focal lengths the Tele-Tessar can be used to achieve special effects in composition, e.g. to separate a subject from its background or to "gather up" the perspective.

Specification:

Elements	4
Groups	4
Focal length	341.2mm
Angular field	diagonal 13°, side 9°
Aperture range	5.6-45
Filter connection	screw thread for Hasselblad series 86
Closest focusing distance	4.5m
Weight	approx 1350g
Length	226.5mm

Tele-Apotessar CF 500mm, f/8

The new Tele-Apotessar lens has been designed using special glasses of extreme optical properties. Compared with its predecessor, the chromatic aberrations have been drastically reduced. For example, the axial focal shift (due to secondary spectrum) between the wavelengths 546nm and 656nm was reduced to less than half of its former amount. Lateral color has decreased accordingly, hence pictures of subjects with high contrast do not show any color fringes on bright/dark edges.

A special feature of the Tele-Apotessar lens is its internal focusing, i.e. the lens is focused by moving the rear group while the front group remains stationary, so the mechanical length of the lens does not change during focusing.

Another important point is the improved image quality at close range. At the shortest distance setting of 8.5m, the lens gives a significantly better corner image than the former 500mm Tele-Tessar lens.

Specification:

Elements	5
Groups	3
Focal length	499.3mm
Angular field	diagonal 9°, side 6.5°
Aperture range	8-64
Filter connection	Hasselblad series 86
Closest focusing distance	8.5m
Weight	approx 1810g
Length	329mm

Variogon CF 140-280mm,f/5.6

This zoom lens for the Hasselblad is made by Schneider. The focal length range covers the most common focal lengths selected by Hasselblad photographers. A focal length scale is engraved 140-160-180-210-250-280. The wide, studded setting rings allow very quick focal length and focus changes. The Variogon was the first zoom lens to be provided with a macro capability.

Specification:

Elements	7
Groups	5
Angular field	diagonal 16-30°, side 11-22°
Filter connection	bayonet for Hasselblad series 93
Closest focusing distance	normal 2.5m, macro 1.07m
Weight	1870g
Length	240mm

F LENSES AND TCC LENSES

F and TCC lenses have no shutter. The focusing mount bayonet is fitted with the necessary coupling for the automatic diaphragm. The TCC lenses also have four contact pins for data transmission between the lens and the 205TCC camera body. TCC lenses are distinguished by two blue lines on the left side of the aperture ring.

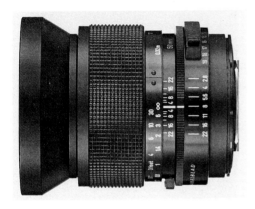

Distagon F and TCC 50mm,f/2.8

Thanks to the superb correction of distortion and all monochromatic and chromatic aberrations, the image quality of this lens is excellent. The design is remarkably compact despite the speed and large angular field.

Aberration correction for close range is by floating element.

Specification:

Elements	9
Groups	8
Focal length	51.7mm
Angular field	diagonal 75.5°, side 57°
Aperture range	2.8-22
Filter connection	screw thread M86x1
Closest focusing distance	0.32m
Weight	approx 1240g
Length	112mm

Planar F and TCC 80mm,f/2.8

The optical design of this lens is the same as the CF version.

Compared with the CF version, the extension of the helical focusing mount and thus the range of the distance setting has been considerably increased.

This lens can virtually be used in all fields of general photography.

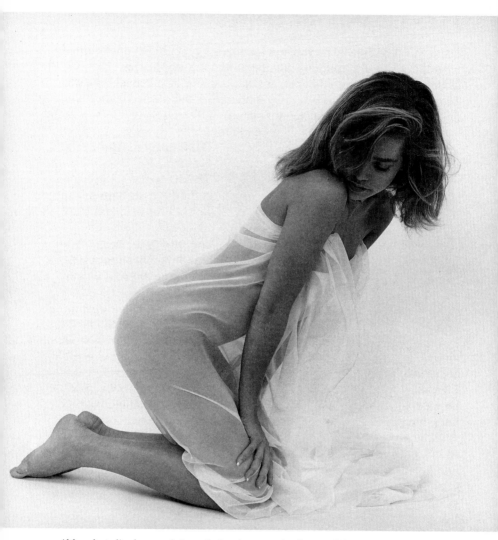

Although studio glamour photography has degenerated to images of the "page three" type in most cases, some photographers still produce wonderful images in this genre. Photographer Robert Benton produces some of the most attractive images I have seen.

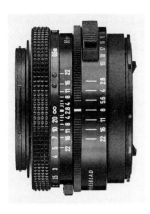

Specification:

Elements	7
Groups	5
Focal length	80.5mm
Angular field	diagonal 52°, side 38°
Aperture range	2.8-22
Filter connection	bayonet for Hasselblad series 50
Closest focusing distance	0.6m
Weight	approx 410g
Length	62mm

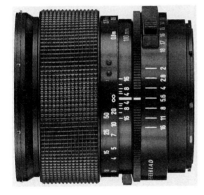

Planar F and TCC 110mm, f/2

This lens is distinguished by a uniform and superior definition over the entire image field.

Its speed, the angular field and the excellent image quality make it extremely versatile. Its main field of application will be sports and press photography with extremely short exposure times, hand-held shots even under unfavorable lighting conditions, photographs of individual persons and groups as well as portrait photography.

Specification:

Elements	7
Groups	6
Focal length	110.8mm
Angular field	diagonal 40°, side 28.5°
Aperture range	2-16
Filter connection	bayonet, size B77
Closest focusing distance	0.8m
Weight	approx 750g
Length	87mm

Sonnar F and TCC 150mm, f/2.8

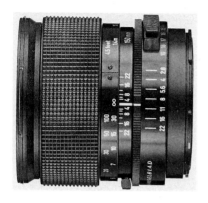

The 150mm Sonnar f/2.8 lens is a fast high-performance lens of medium focal length. It is a first-class lens of extraordinary versatility. It is suited for sports and portrait photography and allows - thanks to its relatively high speed - hand-held exposures under unfavorable lighting conditions. In portrait photography this lens guarantees a correct perspective and permits the elimination of confusing and thus disturbing background by using full aperture.

Specification:

Elements	5
Groups	4
Focal length	151.1mm
Angular field	diagonal 29.5°, side 21°
Aperture range	2.8-22
Filter connection	bayonet, size B77
Closest focusing distance	1.4m
Weight	approx 680g
Length	87.5mm

Tele-Tessar F and TCC 250mm, f/4

Even at full aperture the 250mm Tele-Tessar f/4 lens provides excellent image quality. This lens is a true tele lens and hence very compact and relatively light.

Applications are many. It is suitable not only for long-range photography and portraiture but also, owing to its relatively high maximum aperture, for press, sports and stage photography.

Specification:

Elements	5
Groups	5
Focal length	246.3mm

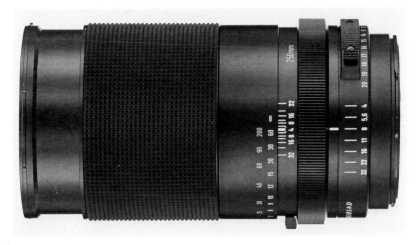

Angular field	diagonal 18°, side 13°
Aperture range	4-22
Filter connection	bayonet, size B77
Closest focusing distance	2.5m
Weight	approx 920g
Length	156mm

Tele-Tessar F and TCC 350mm,f/4

The 350mm Tele-Tessar f/4 lens, with its long focal length and wide maximum aperture is characterized by outstanding quality. It has internal focusing and a minimum focus of 1.90m.

It is particularly suited for use with the Mutar 2x converter. This combination results in a high-quality telephoto lens with the relative aperture of f/8 and the focal length of 700mm.

Specification:

Elements	8
Groups	6
Focal length	350.3mm
Angular field	diagonal 13°, side 9.2°
Aperture range	4-32
Filter connection	thread M96x1mm, screw-in type slip-on, dia. 100mm
Closest focusing distance	1.9m internal focusing

Close-limit field size	226x226mm
Weight	approx 2000g
Length	258mm

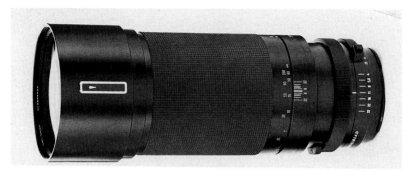

Variogon F and TCC 140-280mm, f/5.6
This is the F version of the Schneider zoom already described in its CF version.

Mutar 2x Teleconverter
The Mutar 2x teleconverter is inserted between the lens and the camera using a bayonet mount. The converter doubles the focal length of the lens and reduces the relative aperture set on the lens by two f/stops. Exposure time is therefore quadrupled.

Focusing of the lens is virtually unaffected by the Mutar 2x converter.

Using the image plane as a reference, the distance setting changes only by the mechanical length of the Mutar (65.4mm). The converter has been calibrated in such a way that all lenses combined with it can be set to infinity. This results in some lenses having the infinity setting in front of the infinity symbol on the focusing scale. For this reason, you should always use the focusing screen of the camera for focusing.

The number of available focal lengths is considerably increased by the use of a Mutar 2x teleconverter. Its low weight of barely 420g makes it the ideal unit for hiking and mountaineering, or for animal and sports photography.

Attaching the Mutar 2x converter: Make sure that the camera is cocked and not pre-released (S-released). The transmission key of the Mutar 2x must be cocked and its slot must be aligned with the red index mark. If the key is in the released position, insert a coin (or similar) into the slot and turn clockwise. The converter is mounted on the camera in the same way as an extension tube or a lens. After this, insert the lens into the large bayonet of the Mutar 2x.

Warning: The 135mm Makro-Planar f/5.6 lens or the converter can be damaged if you try to mount the lens directly on the converter. For use of this lens with the converter, a variable extension tube or an automatic bellows unit must be inserted between the converter and the lens.

Removing the Mutar 2x converter: First remove the lens and then the converter from the camera. It is also possible to remove the Mutar 2x and the lens combination as an entity from the camera.

If you separate the converter and the lens after removal from the camera, there is the risk of both devices being released. In this case, you would have to manually recock both the converter and the lens.

The sharpness and contrast of the Zeiss Hasselblad lenses are amply demonstrated in this night shot (right) of intricate detail by Mark Vsciak. The fine detail makes or breaks a photograph such as that above by Richard J. Cann who used a 250mm CF lens.

This is how many professional photographers feel at the end of a long shoot!
Photo by Barry Hayes.

6: Picture Taking with Hasselblad Cameras

USING HASSELBLAD LENSES

The Hasselblad cameras are very easy to operate once the basic operations described in Chapter 4 are mastered.

It is important to realize that all 500C and later cameras have the same lens mount type, but that there are four different sets of lenses which might be fitted to them. Originally the lenses were all mounted with Compur between-the-lens leaf shutters and these lenses are designated as **C** lenses. Later these lenses were redesigned around a new Prontor shutter, and designed for ease of use also on the cameras with shutter in the camera body. These lenses are designated **CF**. Then followed the line of lenses made specifically for the 2000 series of cameras. These lenses have no built-in shutters at all, and are designated as **F** lenses. Lastly the new lenses for the 205TCC camera are identical to the F lenses but feature a set of four electrical contact pins on the rear surface to convey information to the camera body. These lenses are designated **TCC** lenses.

All of the 500 series camera bodies lack shutters, so they can only be used with the C and CF lenses for general photography. These cameras do have, however, a secondary light baffle at the back to protect the film from stray light. This light baffle opens up when the shutter release button is pressed in and closes when the button is released. Since the baffle will close whenever pressure is released on the shutter release button, it is important with these cameras to keep the shutter release button depressed until the shutter has closed. At most speeds this is not a problem, since the shutter closes rapidly, but when using slower speeds it is important to remember this and keep the button pressed until you hear the soft click of the closing shutter.

When using the self-timer (**V** position on VXM lever) on the C lenses, it is important that the light baffle be open when the shutter trips after about 8 seconds. This is accomplished by setting the small lever on the

Chinese artist in Shanghai. Photo by Jan Meyer.

shutter release button's base to the **T** position prior to release. This **T** position holds the baffle open until moved back to the **O** position. This O/T lever may also be used to hold the camera shutter open when set to **B** for long time exposures.

C and CF lenses may be used on the 2000 series and 205TCC with the camera body shutter control set to the **C** position. In this case the camera is functioning fully mechanically and will work with an exhausted battery or no battery at all. When used in this way the camera body shutter is functioning only as a secondary light blind, and will remain open only so long as the shutter release button is depressed, so the button must be held in as on the 500 cameras until the shutter in the lens has closed.

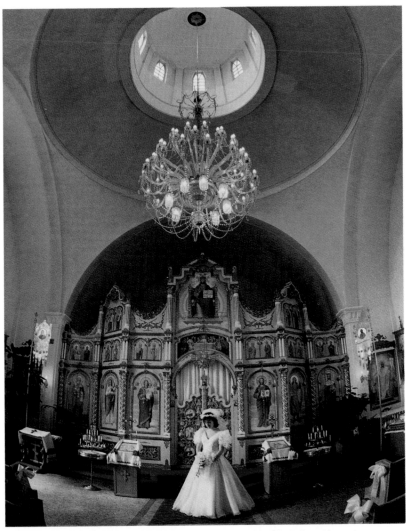

For this award-winning bridal portrait, Canadian photographer Ilija Galic used a very untraditional lens, the 30mm Fisheye Distagon. This goes to show that breaking the rules can work, and produce highly distinctive images.

CF lenses may be used on 2000 series and the 205TCC cameras for general photography by setting the lens shutter control to the F position and then operating normally for the cameras as with F lenses. CF and F lenses must be operated with their diaphragms stopped down to meter correctly with the 205TCC's built-in light metering system.

Since the 2000 series cameras have no self-timer, and the self-timer on the 205TCC can not be used in the C setting, these cameras are not suited to delayed release operation with C type lenses. If self-timer operation is desired on the 205TCC it is important to use the camera body shutter, regardless of the type of lens in use, therefore excluding use with C lenses. On CF lenses, simply set the shutter dial to F and use the camera's shutter dial to set the shutter speed, or operate the camera in one of its automatic exposure modes.

CONTROLLING DEPTH OF FIELD

When we look at a selection of photographs one thing which can be seen is that the portion of the image which is in sharp focus varies. In some photos only a small section of the image is in sharp focus with the balance being more or less out of focus. In other photos every detail throughout the image is sharp. What you are seeing here is the visible effect of a photographic phenomenon known as depth of field.

Depth of field may be defined as the zone of acceptable sharpness before and behind the actual plane of focus. In truth any lens is only producing its sharpest focus at the plane on which is it focused, but in practice there is always a zone both in front of and behind this plane that is rendered acceptably sharp. This is not a random process, but is controlled by several different factors.

The first and most important factor in determining depth of field is the size of the opening of the iris diaphragm. The larger this opening the shallower the depth of field will be, the smaller this opening the greater the depth of field. By careful selection of lens aperture the depth of field can be adjusted to properly match the desired characteristics of the photo. In scenics and travel photos it is generally desirable to have a great depth of field so that both subjects close to the camera and those in the distance will be rendered sharp.

However there are many other situations in which a great depth of field may not be desired. When taking portraits, for example, it is

frequently desirable to limit the depth of field to not much more than the subject's face so that potentially distracting background elements will be rendered out of focus and soft. This shallow depth of field may also be appropriate to photographs of flowers and animals and in any situation in which a single subject is to be given prominence and the background reduced in importance.

The second factor which affects depth of field is the focal length of the lens in use. Hasselblad lenses shorter than 80mm are generally classed as wide-angle and those longer than 80mm generally classed as long focus or telephoto. What is important to know about focal length and depth of field is that the depth of field will decrease as the focal length of the lens increases at the same subject distance and the same aperture. That qualification is important, as will be seen later.

It would seem from this that a case could be made for using wide-angle lenses whenever great depth of field is desired and telephoto lenses whenever shallow depth of field is desired. Although somewhat over-simplified, this is generally true in practice.

Once you have decided on your subject and composition just how can you tell what the depth of field will be? There are three ways. The first, and by far the least practical, is to always carry a set of printed universal depth of field tables with you and consult them for every photo. Such tables are given in many photographic reference books and will allow you to compute depth of field given the lens focal length, film format, subject distance and aperture. The second method for determining depth of field is a little easier but much less precise. It uses the depth of field scale which is combined with the focusing scale on all Hasselblad lenses with focusing mounts.

Once the lens has been focused this scale can be consulted. In our example we are assuming that the lens came to focus at just under seven meters or roughly 20 feet. We are using an aperture of f/8 for our photograph. By looking at the two places on the scale where 8 is shown we can see the approximate limits of the depth of field at this aperture. In this example the depth of field would extend from about 4.5m at the near end to about 15m in the distance. If we had chosen to use f/22 instead, the depth of field would have extended from under 3.5m to infinity. Due to space limitations on the lens barrel and necessarily vague markings on the distance scale this method is obviously good only for very approximate determinations of depth of field.

The third method by which depth of field may be determined is by

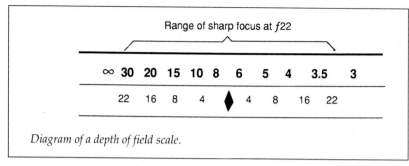

Diagram of a depth of field scale.

direct viewing. It must be remembered that the Hasselblad SLR cameras, in common with all modern SLR cameras, always show the viewing image with the lens open to its largest aperture. This is to provide maximum brightness for your viewing and focusing. When you take a photograph the lens diaphragm is closed down to the selected opening size just a fraction of a second before the shutter opens to make the exposure.

To visually preview the depth of field it is necessary to close the diaphragm down to the selected opening size. Hasselblad lenses have a key which is pressed downward to close the diaphragm to its set opening size. This locks into place, but may be released by pressing in on the lower end on CF, F and TCC lenses and may be re-opened on C lenses by turning the aperture ring to fully open and back again to the selected aperture.

Although the most obvious effect of the diaphragm's closing will be an overall darkening of the viewfinder, a careful inspection will show that it is possible to see which portions of the image are in focus and which are not. This takes some practice while you teach your eye not to strain at the dimmer image but just to relax and let you inspect the screen for image sharpness. Once you have gotten the knack of using this you will consider it a valuable tool in controlling your photos to get exactly the effect you want.

LIGHT METERS AND METERING TECHNIQUE

Separately I have dealt with the built-in meter featured by the Hasselblad 205TCC camera and the operation of the Hasselblad metering prism

finders. Essentially there are two types of light meters, those which read light reflected from the subject, as all of the Hasselblad through the lens meters do, and those which read the light falling on the meter itself.

In addition to using the Hasselblad 205TCC with its own internal spot meter, or the metering prism finders, there are times when the photographer may prefer to use a separate hand-held light meter.

There are a number of very good light meters on the market today, most of them quite accurate. When using a separate hand-held meter for measuring reflected light, it is very important to know the acceptance angle of the meter. Some light meters measure light from a very broad acceptance angle, while others measure a much narrower angle of view.

Below: To produce exactly the effect I wanted for this photograph, I used the Zone system approach, taking a number of highlight and shadow readings with a spot meter and then exposing and processing accordingly. Photo by Bob Shell.

The instruction manual which comes with the meter should state what the measuring angle is. Some meters feature optical viewfinders which allow the photographer to visually confirm the area being metered, while others simply rely on the photographer to guess the approximate area being metered.

Over the years I have used a number of different meters, and have found those made by Gossen and Sekonic to be very good. Currently, I use one of the Gossen Ultra-Pro meters for general, broad angle metering, and the Gossen 1° spot meter for critical spot metering. I find them both extremely accurate, but I have settled on the spot meter for most of my critical metering needs. If I were to begin using the 205TCC as my regular camera, I would dispense with the separate spot meter because the camera duplicates most of its functions and I can select the metering angle by changing the lens.

Users of the Zone System will find that they absolutely require an accurate spot meter, and both the built-in spot meter in the 205TCC camera and the Gossen 1° spot meter have a Zone System mode which simplifies use for Zone calculations.

I have found in my own photography that the spot and limited angle meters are most useful to me when doing black-and-white photography. I can meter both the shadow and the highlights and make sure that the film can accomodate both, and adjust the processing to match the film latitude to the subject brightness. This is basically what the Zone System does, and sometimes I use it in it full application, while other times I simply do a quick mental approximation, depending on the time I have and type of photography.

The one limitation of all reflected light meters is that they are calibrated to assume a subject of average reflectance, an 18% gray, and will give false readings when working with subjects with greater than or less than average reflectance values. One solution to this problem is to carry a photographic gray card at all times and to take meter readings from the gray card rather than the subject. The Gossen spot meter even comes with a packet of small gray cards with adhesive on the back to allow them to be stuck all around the area to be photographed for accurate multiple readings. In practice, I have not found this very practical, and I simply make a mental compensation when the subject has greater or lesser reflectance.

One old-time photographer's trick is the use of the palm of your hand as a substitute gray card. Most people do not tan much on the palms of

When photographing a subject with dark skin it is important to remember that a reflected light reading will not yield correct exposure. For this masterful studio portrait, photographer Harry Wade had to meter carefully, taking into account that the model's skin tones are darker than the 18% gray to which light meters are calibrated.

their hands, so the tone of the palm is likely not to vary much year round. In most caucasians, the palm of the hand is about one stop brighter than 18% gray. If you want to "calibrate" your palm, take a reading of a gray card and then one from your palm under the same light and see how much difference there is, and use that factor in future computations.

You may also find, as I do, that the skin tone I like best on my models is about one stop brighter than 18%. When working with a model who is not deeply tanned, I will use a meter reading off the model's cheek or

Silhouette photos require very careful exposure for maximum effect. Here the 500mm CF lens was used with a 500ELX camera to narrowly focus the scene. (Photo by Richard J. Cann).

a similar area of smooth skin and calculate the exposure based on this reading, factoring in the one stop difference. In the case of deeply tanned models, or men with ruddy complexions, I will either assume that I want to match the skin tones to 18% or only compensate a little, usually less than half a stop.

When working in color, primarily when working with color transparency films, the Zone System is of limited use because there are really no practical ways to alter the latitude of color transparency films in processing. The film can be pre-flashed to lower contrast, but that is a difficult process to control and far beyond the capabilities of most photographers, and often the tonal range of the subject can be subdued with fill flash, but most of the time the film simply has to be used in situations in which either maximum highlight detail or minimum shadow detail are lost.

For proper exposure of color transparency films under most lighting situations, I find that metering with an incident meter, a meter which measures the light falling on the meter itself, gives me the best results. Incident meters are easily recognized by their half-sphere shaped white receptors. In use the meter is held near the subject, or under the same light falling on the subject when that is not possible, and the dome is pointed toward the camera lens for the reading. This gives an averaged reading integrating both highlight and shadow. Since the meter is reading the light falling on the hemisphere receptor, it is not affected by the reflectance of the subject, and no compensation is necessary for photographing very light or very dark subjects.

When photographing people, I use the incident meter to take a reading with the receptor of the meter directly in front of the subject's face, pointing toward the camera lens. This assumes that I want the face to be

exposed most carefully. Should the emphasis be on some other part of the subject, then I would place the meter there for the reading, but always pointing the receptor toward the camera. When I see beginners using incident meters I often see them waving the meters about all over the place to get their readings, when this simple method of always pointing toward the camera lens is all that is necessary.

Incident meters may also be used to determine the contrast range or lighting ratio in a scene. To measure the highlight level, the meter's receptor is pointed directly at the light source and a reading is taken. Then to measure shadow level, the meter is turned 180° and a reading is

Photos like this require good metering technique and a sturdy tripod. Stunning results like this make the effort worthwhile. (Photo by Paul R. Comon).

taken with the incident receptor pointed directly away from the light source (at which time it is responding to the ambient reflected light, the light reflected into the shadows by the surroundings). The difference between these two readings is the lighting ratio; for example if there is a one stop difference, then the ration is 2:1, twice as much light is striking the highlights as is being reflected into the shadows.

Most incident meters come with removeable incident domes, and usually are supplied with one or more accessory sensor diffusers. One of these is usually flat, and is intended for taking incident readings when copying flat artwork and other flat materials. If you find that you need to take meter readings for copy jobs, do not try to do so with the hemisphere in place, always use the flat diffuser for best results. By moving the diffuser to various positions on the work to be copied the degree of light variation can be easily seen, and the lights can be adjusted to provide even illumination, a must for quality copying.

Some incident meters also offer accessories which convert them to reflected type meters and even to semi-spot meters, which can greatly enhance their versatility. If I could only afford one meter, a good incident meter would be my choice.

Many modern meters can measure electronic flash as well as ambient light. If you intend to use electronic flash at all in your work it is worthwhile to buy a meter which will read both, since they are not usually that much more expensive than meters that will read only one or the other. If you intend to do much location work in which flash will supplement ambient light, it is important to have a meter capable of reading both and producing an integrated reading of the two. Not all meters capable of reading both flash and ambient can read the two simultaneously, so find this out before purchase if it will be important in your work. Also, if you intend to do a lot of product photography or still life photography in a studio, you may want to have a meter which is capable of reading multiple firings of the flash, since such photography is often done with multiple pops of the studio flash. The best meters for this sort of work can read a single flash and display the number of flashes which will be necessary for correct exposure at a particular aperture. In recent years light meters have become more and more sophisticated and accurate, if you have not looked at the recent crop of light meters you owe it to yourself to make their acquaintance.

A special class of meters is called color temperature meters and are capable of analyzing the ambient light and reading out the color tempera-

The soft and subtle tones of this black and white glamour image require detailed knowledge of studio lighting techniques as well as careful exposure, processing and printing.
Photo by Robert Benton.

ture of that light as well as a correction filter factor. For extremely critical photography in unusual light, these are sometimes necessary, but I have not found them worth the rather high cost for general photography. For those rare times when a color temperature meter or other unusual accessory may be needed, it may make more sense to rent from a major dealer.

7: Hasselblad System Accessories

The Hasselblad system features a very wide array of accessories. This creates a flexibility allowing Hasselblad cameras to be custom adapted to practically any type of photography. Because Victor Hasselblad was an avid wildlife photographer, many of the accessories were developed with this type of photography in mind, so the system is particularly versatile for closeup photography.

LENS SHADES

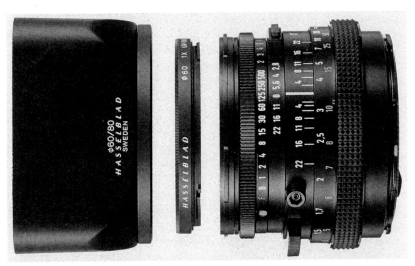

40670 lens shade for 80mm CF, F and TCC lenses with 60mm bayonet.

Even the very best lens will suffer from flare in certain situations if not properly shaded from extraneous light. For this reason, Hasselblad offers an extensive line of lens shades. For the normal 80mm CF, F and TCC lenses the 40670 is the proper shade. Since this fits the 60mm

bayonet of the newer lenses, an adapter must be used to fit this shade onto the older F type lenses. This adapter is the 40711 step-up ring.

For CF lenses with focal lengths from 100 up to 250mm, the 40673 lens shade is the correct one.

The newer 40mm Distagon CF uses a special shade which is supplied with the lens. In the event of loss or damage, this shade may be ordered as number 40693. It also serves the dual purpose of acting as a holder when using 93mm threaded filters on the 40mm Distagon lens.

The 350mm Tele-Tessar CF and the 500 mm Tele-Apotessar CF lenses both use the 40703 lens shade, which comes with the lenses. It may be ordered as a replacement for these lenses if lost or damaged, and also fits the older 350mm and 500mm Tele- Tessar C lenses. Since the shade accepts 93mm threaded filters, it may be used with these lenses to allow the use of these instead of the discontinued 86 mm threaded filters accepted directly by these lenses.

The 50mm Distagon F and the 50mm Distagon TCC lenses accept the 40706 lens shade, supplied with the lenses. This shade may be bought as a replacement or for earlier lenses with which it was not included, and allows the use of 93mm threaded filters on these lenses in place of the 86mm threaded filters which have been discontinued.

For F and TCC lenses of focal lengths from 110mm through 250mm the 40576 is the proper shade.

Hasselblad Professional lens shade with mask in place for longer focal length lenses.

For the 350mm Tele-Tessar F and TCC lenses the proper shade is the 40717. It also incorporates a filter holder for 93mm threaded filters.

Many photographers prefer to use a "professional" lens shade instead of these lens-specific shades. The professional shade is an extendable bellows with focal length markings on the rails so that it can be set for maximum shading of various lenses. For longer focal length lenses, a mask is inserted into the front of the bellows to further restrict the light striking the front element of the

lens. This type of lens shade offers the ultimate in flare prevention, and the greatest versatility since one shade can be used on many lenses. However, the initial investment for the shade and needed adapters is rather high.

There are two different professional shades, the 40676 which is usable on lenses with 50, 60, 63 and 70mm diameter fronts, and the 40726 which fits lenses with 93mm diameter fronts. Because the front component of the 50mm Distagon F and TCC lenses rotate during focusing, a special guide bracket (# 40729) must be used with the 93mm lens shade on these lenses. This prevents rotation of the lens shade which would cause vignetting of image corners at certain focusing positions.

The 40676 Professional Lens Shade does not attach directly to the lenses, but must be attached with a Lens Mounting Ring. These rings are available in a variety of sizes for all of the Hasselblad lenses. Each ring is also fitted with a slot for use with gelatin filters. The appropriate Lens Mounting Rings are:

For older C and F lenses accepting 50mm filters, the 40679; for lenses accepting 60mm filters, the 40681; for lenses accepting 63mm filters, the 40684; and for lenses accepting 70mm filters, the 40687. If you are unsure of the filter size of your lens, refer to the lens/filter size table in the chapter on filters.

FOCUSING SCREENS

Over the years, Hasselblad has offered a variety of focusing screens for their cameras. Prior to the 500CM and ELM models, the screens had to be changed by a repair technician. All recent models have user interchangeable screens.

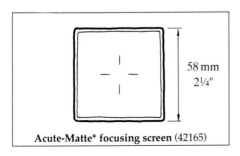

Acute-Matte* focusing screen (42165)

58 mm
2¼"

On cameras in which focusing screens are user interchangeable, there are two chromed sliding clips which hold the focusing screen in place. To remove the screen, these two clips are pushed aside with a fingernail or ballpoint pen and the camera is inverted over the photogra-

pher's hand or a clean cloth. The screen should simply drop out. If not, the lens is removed and the photographer reaches in through the lens mount and gently pushes the screen free, preferably with a clean cloth covering the finger to keep smudges off the screen.

The replacement screen is simply dropped into place and locked in by replacing the viewfinder. Make certain that the screen is right way round before dropping in by looking at the frame. The smooth, single piece frame surface is the upper side.

In spite of the best efforts by photographers, focusing screens do get dirty. The upper surface of Hasselblad screens is smooth and not easily harmed, and may be safely cleaned with lens tissue or a clean cloth moistened with lens cleaning fluid. However, the lower surface of most of the screens contains textured elements which cannot easily be cleaned in such a manner without leaving lint behind on the screen. It is safest to clean the lower surface with compressed air. In cases of serious collections of dirt and grease on the lower surface, it is best to refer the screen to a qualified service technician for cleaning. If the

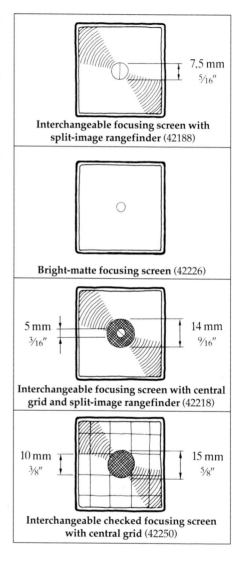

Interchangeable focusing screen with split-image rangefinder (42188)

Bright-matte focusing screen (42226)

Interchangeable focusing screen with central grid and split-image rangefinder (42218)

Interchangeable checked focusing screen with central grid (42250)

Interchangeable plain glass screen (42200)

screen is badly scratched or abraded, it is best to replace it.

Focusing screens vary in brightness, and there are some now on the market from independent suppliers claiming much greater brightness than the factory screens. Care must be exercised in evaluating such claims. Although it is somewhat of a simplification, an inverse relationship does apply between brightness and contrast. Therefore, the brightest screens will have the least contrast, and vice versa. Since your eye responds to contrast as well as detail in the focusing process, the brightest screen is not necessarily the easiest to focus. My suggestion to photographers contemplating the purchase of alternative screens is to try them first and determine if you will be able to focus with them, particularly in dim light.

At any rate, whenever changing screens, whether to factory supplied or alternative versions, it is important to understand that changing the screen will affect the calibration of any Hasselblad metering prism, since these determine their exposure information by reading from the surface of the screen. Changing screens may require inputting a correction factor to get correct exposure from the metering prism.

All current Hasselblad cameras are supplied from the factory with the Acute-Matte screen (# 42165), a joint development of Hasselblad and Minolta. This screen combines the greatest brightness with a reasonable level of contrast for ease in focusing. The Hasselblad 205TCC is supplied with a special Acute-Matte screen with the metering area indicated with a dotted circle.

The Bright-matte focusing screen (# 42226) is an alternative to the Acute-Matte. While not as bright, it offers greater focusing contrast and may be preferred by some photographers.

The focusing screen with split-image rangefinder (# 42188) is similar to the Bright-matte, but fitted centrally with a dual prism which splits lines when they are out of focus and unites them when in focus. This split-image rangefinder is 7.5mm in diameter, and has an angle best suited for focusing lenses up to 150mm in focal length. It may be inserted into the camera with the axis of the split image either horizontal or vertical to best match the type of subject.

The focusing screen with central grid and split-image rangefinder (42218) combines a smaller (5mm) split-image rangefinder with a 14mm surrounding microprism (Dodin prism) focusing area.

The checked screen with central grid (# 42250), also referred to as the architectural screen, has a grid pattern for horizontal or vertical alignment of subjects combined with a central, 15 mm diameter, microprism.

The plain glass screen (# 42200) is used for photomicrography and other types of photography in which the aerial image is focussed rather than the projected image on the screen. It is fitted with a fresnel lens to enhance brightness and has a cross-shaped reticle for ease in focusing.

An unusual accessory for use with the focusing screens is the 41025 focusing screen adapter. This is a plate which attaches to the rear of the camera body in place of a film magazine and accepts the above focusing screens for direct viewing. It was originally designed for use on the Super Wide cameras for those times when precise focusing and framing are essential, but may also be fitted to the 1000, 500, 2000 and 205TCC series cameras. In addition to accepting any of the interchangeable focusing screens, the adapter also accepts any of the viewfinders.

GRIPS AND RELATED ACCESSORIES

While it is possible to use any of the Hasselblad cameras without accessory handgrips, most photographers favor the use of a grip for a better feel and easier operation. There are currently two handgrips available, similar in design but operating with different cameras. The Model 1 operates with the manually advanced 500 cameras, with the 2000 series and with the 205TCC. The Model 2 operates with the 553ELX and any of the 500EL series. The current versions of these grips come with a reversable 1/4 and 3/8 inch bolt for attaching to the camera and thus are easily fitted to cameras with either tripod bushing in place.

Previously there were other types of grips offered, but they haved been discontinued. The under-camera pistol grips and the rifle-stocks for long tele lenses are often encountered in the used market.

One important accessory for any Hasselblad camera is the tripod quick coupling (# 45129). This is a small plate with a locking lever which is attached to the tripod head and left there. Once in place, it quickly accepts the camera, which is locked by a flip of the lever. This allows very rapid fitting and removel of the camera, and allows quick interchange in

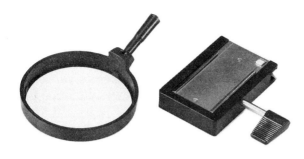

multiple camera setups.

Although the current Hasselblad lenses feature broad, textured focusing rings with easy grip, some photographers still prefer to use a quick focusing handle. The # 51700 is still in production and can be fitted to the 40 through 80 mm CF lenses. Older quick focusing rings were offered for C lenses and can frequently be found in the used market. If purchasing one of these rings, make certain that it will properly fit the lens you intend to use it with.

Left: *Quick focusing handle*. Right: *Tripod quick coupling.*

WINDING ACCESSORIES

Winder 2000FCW

Hasselblad originally conceived their cameras as manually advanced machines. When demand for motorized cameras became great, they developed the 500EL series of motor-integrated cameras, rather than develop an add-on motor for the 500C series. Some other independent makers have offered motor winders for 500C series Hasselblad cameras, but Hasselblad has not been involved in their development and cannot approve of them. Should one of these motors damage a camera it is not covered under Hasselblad's warranty.

However, after introduction of the 2000-series cameras, Hasselblad became convinced of the need for an add-on motor winder for these cameras. Special camera bodies called 2000FCW and 2003FCW were therefore developed which could accept an accessory motor winder.

This winder is easily attached and detatched from the camera after removing the standard winding crank. It is powered by 5 AA-size cells, either standard alkaline-manganese or rechargeable NiCd types. The rechargeable cells produce about 1000 exposures per charge, while the alkaline-manganese cells produce about 4000 exposures per set. The maximum speed with the winder is about 1.3 frames per second. The winder also works with the 205TCC camera.

The knob with exposure meter is an accessory which has been in the Hasselblad line for many years. It was originally designed for use with the 500C cameras, and can fit onto any of the manually advanced 500 series cameras. It produces a direct readout in EV numbers which are then transferred to the EV scale on the C or CF lenses. It is a selenium cell meter and therefore needs no batteries or other power source. However, it is not as precise a meter as the metering prisms or the built-in meter of the 205TCC and should be used only as a general guideline in making critical exposures. It has an ISO scale from 6 to 1600, and is equipped with a sliding diffuser to allow incident readings to be taken.

ACCESSORIES FOR EL CAMERAS

The 500EL and its successors the 500EL/M, 500ELX and 553ELX are all motor-integrated cameras accepting the C and CF series of lenses.

Operationally, they function similarly to the 500C series of cameras except that film advance and shutter cocking is motor driven rather than hand-cranked. Originally they were designed only for operation with rechargeable NiCd batteries, but the current model accepts AA cells as well. If using one of the cameras powered by NiCd batteries, it is important to follow the instructions for battery charging and care. NiCd batteries may be damaged by excessive charging, so do not leave a battery on charge longer than 14 hours, and always use a battery until the camera begins to slow down before recharging. This will maximize the life of the battery.

As an accessory, the Recharge Unit III was available until recently, and incorporated a built-in timer. The Recharge Unit I, supplied with the camera, incorporates no such timer, and can harm the battery if used improperly. My suggestion is to purchase an electrical outlet timer from a hardware store and use this to govern the charging time to prevent overcharging and battery damage.

The above battery chargers are intended to charge the battery while in the camera. It is often more practical to have two or more batteries, and charge them outside the camera. Battery Compartment 3 is available as an accessory, and allows charging of batteries outside the camera. With a connecting cable, the Battery Compartment 3 can also be used to power the camera with the batteries at a distance - excellent for cold weather work because the batteries may be placed in a photographer's inside pockets and thus kept warm.

The Recharge Unit III, mentioned above, may also be used to power the camera from an AC supply. However, this will not work with no batteries in the camera. To eliminate the need for batteries altogether, Hasselblad also offers an AC transformer unit which may be the most practical means of operating EL series cameras if they are used only in the studio.

During their research on space cameras, Hasselblad developed a shutter release which was a large rectangular plate. This was initially developed for use with the thick gloves worn by the astronauts, but has proved popular with general photographers. It is standard equipment on the 553ELX and 500ELX, but is available as an accessory for all older EL models. For those photographers who prefer a more standard, smaller button, the 46116 Release Button is available, and fits any EL series camera.

Remote release of the EL cameras is possible with a number of different options, some supplied by Hasselblad and others from other suppliers or custom built. Standard remote cables with release buttons are available in lengths of .3 meters and 6 meters for the front sockets of the ELX cameras, and in 1.5 meter lengths for the side socket of all EL cameras. A 5 meter extension cord is available for the side socket connection.

It is possible to trigger the cameras with cables from a much greater distance, but due to line loss an amplifier must be built into the cable. For this reason it makes more sense when working at distances greater than about 6 meters to use an infrared or radio trigger. These are available from a number of independent suppliers and are, in most cases, easily adapted to fire the EL cameras. Should you require such an adaptation, technical staff at Hasselblad's distributor in your country will gladly assist in making recommendations and explaining how to adapt and operate the equipment. Should you have other special requirements, such as operating multiple cameras in synchronization or sequence, operating the automatic aperture control lenses at the same time as

remote release, using intervallometers, etc., consult with the technical staff at your Hasselblad distributor. They are always up to date on what will work with the EL cameras.

CLOSE-UP AND COPYING ACCESSORIES

The Hasselblad camera system offers a variety of accessories for photomacrography and general close-up photography. The most important of these accessories is the Close-up calculator, a slide-rule type of gadget which allows the photographer to determine such factors as lens extension, lens to subject distance, EV reduction and depth of field easily. I have used this calculator extensively, and find it one of the most useful field accessories ever devised for close-up photography. It comes in a carrying sleeve with instructions for use in six languages.

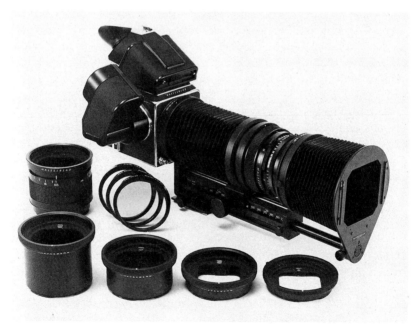

Hasselblad close-up accessories. **Top:** *Camera fitted with Automatic bellows Extension and Adjustable Lens Shade. The flanges on the front of the lens shade accept the Hasselblad Transparency Copyholder for making duplicate transparences.* **Middle:** *left, Variable Extension Tube 64-85, right, Proxar close-up lenses.* **Bottom:** *Extension Tube Set, 56,32,16 and 8mm.*

For general close-up photography there are two ways to approach the problem. The easiest way is to fit close-up lenses over the front of the taking lens to increase the magnification and shorten the lens to subject distance. The advantage of using close-up lenses is that no exposure calculation need be made, since the lens to film distance is unchanged. Readings taken with a standard light meter may simply be directly

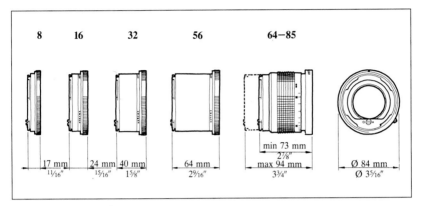

Hasselblad extension tubes

transferred to the camera and lens prior to taking the photo. However, close-up lenses, even the best, will somewhat detract from the resolving power of the prime lens, and typically will not produce a very flat field of focus. For general photography this may not be important, but for critical work such as copying of documents, and duplication of transparencies, this is not acceptable.

The close-up lenses supplied by Hasselblad are the Proxars from Carl Zeiss. Needless to say they are among the best available. They are available

Hassleblad variable extension tube 64-85

in three powers, 0.5, 1.0 and 2.0 and may be combined for increased magnification. They are fully multicoated and come in the 60mm size for many CF lenses. They may be fitted to other lenses with adapters.

For those times when better quality is required, then getting the prime lens at a greater distance from the film is the only way. This is accomplished with either extension tubes or with a bellows adapter. Extension tubes have the advantage of rigidity and ruggedness, but cannot be focussed in very fine increments, whereas the bellows is infinitely variable between its extremes.

Extension tubes are available in lengths of 8, 16, 32 and 56 mm. All except the 8mm fit any of the Hasselblad cameras made since the 500C. The 8mm tube cannot be used with the 2000 or 205TCC cameras because the shutter speed ring is in the way on these bodies. These extension tubes can be attached in any combination to achieve the desired extension.

A somewhat unusual accessory is the variable extension tube 64-85 (# 51691). Basically this works just like the focusing mount on the Hasselblad lenses, and can be used with the lenses, with the fixed extension tubes and even with the bellows. When combined with the special 135mm Makro-Planar CF f/5.6 lens it can provide a focusing range from infinity down to 1.15 meters.

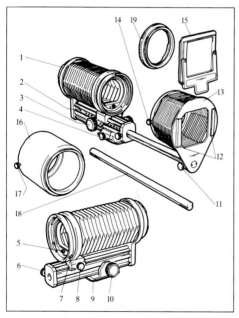

1. Camera mounting ring
2. Bellows extension scale
3. Extension adjustment knob
4. Bellows slide locking screw
5. Key
6. Support rod locking screw
7. Camera lens lock release
8. Extension locking screw
9. Quick-coupling plate
10. Slide adjustment knob
11. Support rod locking screw
12. Transparency copyholder mounting
13. Lens shade (40525)
14. Lens mounting ring locking screw
15. Transparency copyholder (40533)
16. Extension ring (40630)
17. Lens mounting ring locking screw
18. Support rod 296 (40622)
19. Lens mounting ring (40679-40687)

Automatic Bellows Extension and Transparency Copyholder

Robert D Deans, a medical doctor by profession, had a lifelong interest in orchids and photography. He photographed the orchids he grew with the Hasselblad system for years, working with the bellows extension or extension tubes to get the magnification he needed for these often tiny subjects. Sadly, he died during the preparation of this book.

Many portrait photographers like to user a longer lens for the flattened perspective it produces. However, the 250mm lens may not focus close enough for the tight cropping desired. Photographer J. Michael Salema solves this problem by using the short, 8mm extension tube between camera and lens for his studio portraits.

The current Hasselblad bellows is fully automatic, operating both shutter and diaphragm in the lens without the need for a double cable release, as was the case with earlier bellows units. While it can be used with all Hasselblad lenses, it is particularly useful when coupled with the 135 mm Makro-Planar lens, giving a focusing range from infinity down to 1:1 reproduction.

A special lens shade for the bellows is available, and mates to the various lenses with adapter rings which are supplied separately. There

are four of these rings, corresponding to the four current filter sizes; 50mm (# 40679), 60mm (# 40681), 63mm (# 40684) and 70mm (# 40687).

For the use of special lenses with the bellows, the # 40037 lens mount adapter can be bought. This is basically a blank lens board with Hasselblad bayonet on the rear and can be drilled and tapped by a precision machinist to accept a wide variety of special purpose optics.

For slide duplicating with the bellows system, the # 40533 transparency holder is used. It will hold transparencies or negatives for copying with the bellows and lens. However, for slide duplicating purposes, you should be aware that duplicating film is not made in 120 or 220 roll film size, so I have found it more practical to have a custom lab make my 1 2/4 duplicates for me.

I have covered here only the most common accessories which are generally applicable to the Hasselblad photographer. Other special accessories are available from Hasselblad, their subsidiary Hasselblad Engineering AB, and independent suppliers.

FILTERS

Filters are devices which alter the light passing through them and then through the lens in specific ways. Many types of filters may be used on Hasselblad lenses, primarily made from optical glass or optical quality resin. It must always be remembered when considering filters that a filter may restrict certain wavelengths of light by either reflecting or absorbing them, but a filter can only subtract components from the mix of wavelengths presented to it. Thus a filter is a device for removing unwanted aspects of the light presented to the lens, not a device for adding desired aspects.

The lens designers at Carl Zeiss have always preferred to have filters which mount onto the lenses by a bayonet fitting instead of the more common screw thread. The primary reasons for this are that a bayonet fitting is far more resistant to jamming and allows the filter to be fitted to and removed from the lens much more rapidly. For this reason, the Zeiss-made lenses for Hasselblad cameras have bayonet fittings on the front, except in a few cases where bayonet filters in the appropriate size are unavailable.

Most filters are made from flat blanks of optical glass which are cut into a round shape and mounted in metal rings. The filters supplied by

Sometimes the colors make the picture. Here a 60mm CF lens was used with a 500CM camera to capture these. A polarizing filter was used to accentuate the colors. (Photo by Richard J. Cann)

Right: *Photographer Wayne Tang took this striking bridal portrait with the Hasselblad 503CX, normal 80mm lens, and a clear vignetter. Notice that the model is looking away into the distance which gives a dreamy effect to the portrait.*

Hasselblad are of this type. However, many photographers today are using filters which are square or rectangular in shape and are held in frames or adapters which then mount to the front of the camera lens. Makers of such systems nearly always offer adapters with the appropriate Hasselblad-type bayonet mounts for use on Hasselblad cameras. Adapters which convert screw thread filters to Hasselblad bayonet are also available and come in handy when using unusual filters. Another type of filter is the gelatin filter or gel which may also be used on Hasselblad lenses with the appropriate holder. Gelatin filters may be necessary in some cases for color correction or other special purposes, but because of their fragility I do not recommend them for everyday use.

The quality of filters is very important. Nothing will degrade the image quality from an exceptionally good lens more than fitting it with a cheap filter. For this reason, I suggest using only the very best filters on your Hasselblad lenses, since they will degrade the optical quality much less. Unless required for the photo, leave the filters off. The common practice of using a clear glass or UV filter as a lens protector and leaving it on the lens all the time is not a good idea except in hostile environments. Any filter will cause some change in focus and some loss in lens quality, and because the Hasselblad lenses are so very good it is a mistake to dull their sharpness except when essential. For this reason I have become known for the fact that I am rarely seen with a filter of any sort on my cameras.

The one exception to this "no filters unless necessary" is the Carl Zeiss 30mm Fisheye lens. This lens has been specifically computed to work correctly with one of its internal filters used, and must always be fitted with one of them. Since these filters are internal, they have no detrimental effect on the optical quality of the lens.

When using filters on wide angle lenses it is extremely important to use only those filters which are thin enough in profile so as not to block or vignette the corners of the image. All Hasselblad filters made for these lenses will work correctly as they have been made specifically for use on these lenses. However, when using other filters it may be important to find out if vignetting is taking place. To determine this, first fit the filter onto the lens and set the lens diaphragm for its widest opening and the shutter for **B**. Remove the magazine back and point the camera toward a bright light source, and trip the shutter, holding it open.

By pointing the camera toward the light while looking through the back, and tipping it to different angles, it will be possible to see if the light coming through the lens is getting to the corners of the image. If you see

a sudden darkening as the light gets near the corner, you are most likely experiencing filter cutoff. To make sure try again without the filter to see what is normal for the lens in question, as all lenses have some light fall-off. After trying this with the lens wide open, try it again at various apertures to make sure that the corners receive proper light all the way through the range. If you note cut-off at particular apertures, then you know that the filter is unsuitable at those apertures. After this simple visual inspection, you may want to verify your observations with a film test before using that filter on an important job. If you do film tests, make certain to look for any vignetting on the original negatives or transparencies, as the printing process normally cuts off some of the negative area and may hide minor vignetting.

The point to remember in using filters is that they are image modifiers, used to change the character of your image. Filters may be divided into three main categories; those used primarily in black-and-white photography, those used primarily in color photography, and those which may be used with any sort of film.

Filters are made in a great variety of types and colors, and it would be beyond the scope of this book to go into them all in detail. The following discussion will provide the basics. A very good discussion of filters in general and detailed information on specific applications may be found in *Cokin Filter System for Photo and Video* by Heiner Henninges. (Hove Foto Books, 1990. ISBN 0-906447-68-2.)

Filters for Black-and-White Photography

The primary purpose for filters in black-and-white photography is to alter the tonality of the scene. Filters are used in this case to emphasize certain colors of the scene and to de-emphasize others.

A filter of a given color will pass certain wavelengths of light and will absorb all others. Thus a red filter will pass red light, and will absorb both blue and green. In black-and-white photography this serves to give more exposure to the parts of the negative receiving red light, and less exposure to the parts of the negative receiving blue and green light. The areas with more exposure will print as lighter, those will less exposure as darker, so this effectively lightens red subjects and darkens all others. Since filters come in different "strengths", that is different degrees of their color, the effect can be controlled by exact choice of filter. In the

example case of a red filter, these come in light red, medium red and deep red from most makers, and in fine increments of red in Color Correction or CC filters. By proper choice of filter the photographer can determine the degree to which the red areas of the subject will be lightened.

A working example would be photographing a scene in which a bush covered with red flowers appears. In the straight, non- filtered black and white photo the red flowers would be rendered as medium gray, and so would the foliage of the bush, so there would be little distinction between the two. However, the addition of red filtration would lighten the flowers and darken the foliage, and the intensity of the filter would determine the degree of this effect.

Conversely, a green or blue-green filter would have the reverse effect, lightening the foliage and darkening the flowers. By learning to pick out the dominant colors of subjects the black-and-white photographer can learn to see the tonality which will appear in the final photograph. The most commonly used filters for black-and-white photography are yellow, orange and various reds. In landscape photography, for example, one or the other of these is frequently used, because they all darken the sky and make clouds appear with greater definition, yellow having a mild effect, orange a medium effect and red a rather dramatic effect.

To sum up, the main effects are as follows:-

Red: Used in various strengths for darkening blue skies and making clouds stand out. The Deep Red, Number 25, produces a strong effect, and is also necessary for use with infrared color films.

Orange: Somewhat the same effect as the red, but a bit less intense. Produces an effect in between the red and yellow filters.

Yellow: Also used to accentuate blue skies and clouds, but with a more natural looking and less dramatic sky than orange or red. Many landscape photographers use a yellow filter all the time. If you owned only one filter for black and white, yellow would probably be the most generally useful.

Light Green, also **Yellow Green**: Used for de-emphasizing facial blemishes, which are usually reddish in color, in portraiture. It will bring the tone of these blemishes much closer to that of the rest of the skin tones.

UV: This filter is designed to absorb most UV light. In spite of the fact that most optical glass absorbs the majority of UV radiation, some may still get through and cause an overall haze, particularly in long distance landscape photography. Use of the UV filter diminishes or eliminates this haze.

Filters for Color Photography

Of course, black-and-white filters such as those listed above may be used with color films as well. However, they are not used for general photography, but for those special times when you wish to have one color predominate in an image. Most filters intended for color photography are designed to correct for imbalances between film type and light source. Color films are designated for use with specific light sources, light with a particular color temperature, but the light available for photography often has the wrong color temperature.

FL filters: This range of filters is designed to produce a pleasing and relatively accurate color rendition when the primary light source is fluorescent lighting. Often when shooting indoors, particularly in commercial surroundings, fluorescent is the only lighting, and will cause a very undesirable green, yellow-green or blue-green appearance in the finished photographs, depending on the sort of fluorescent tubes in use.

Even the best FL filter may not always be able to produce a pleasing color balance with fluorescent lighting because of the peculiar nature of these lights. They produce light with a very unbalanced spectrum, with spikes of certain wavelengths and a total absence of other wavelengths. Since a filter can only remove unwanted light, not add what is needed, fluorecent light simply cannot always be corrected with a filter. Often the best choice for photography is to turn off the fluorescent lights, or use a shutter speed fast enough to eliminate most of their light, and use electronic flash as the main light source.

If you do decide to photograph with fluorescent light as your primary source, remember that you must use a slow shutter speed regardless of the apparent brightness. Fluorescent tubes pulse, that is they turn on and off, at the same rate as the AC electricity which powers them, or approximately 50 cycles per second in most European countries, 60 cycles per second in the USA. The shutter speed used must be slow enough to bypass this cycling or the photo may be taken during one of the dark phases between pulses. Generally, 1/30 second or slower is required.

Additionally, you must remember that putting a correction filter on the front of your lens means that all the light must be the same. This means that shooting with a FL filter on the lens and attempting to use fill flash will result in photos in which the areas illuminated by the fill flash are too red. The only way this can be done correctly is to use an FL filter on the

lens and the correctly balanced "reverse FL" filter (deep green in color) over the flash. Such "reverse FL" filters are made by Singh-Ray for use with their FL filters, which are the best I have ever encountered.

FL filters come in two basic sorts, **FL-D** for use with daylight type film, and **FL-B** for use with tungsen type film. Additionally, some suppliers such as Singh-Ray make FL filters specifically balanced to different sorts of fluorescent tubes.

This whole subject of correct color balance under fluorescent light is complex and requires much patience and experimentation if good results are to be produced on a regular basis.

The 80 series: When working with photoflood lamps or other tungsten sources and daylight film, these filters allow you to balance the light to the film. While the color balance may not be absolutely perfect, it will generally be adequate for most purposes. If you are using standard photoflood or photopearl lamps with a color temperature of 3200K you should use the 80A filter for proper color balance. If you are using certain types of photographic lamps with a rated Kelvin temperature of 3400K, the 80B is the appropriate filter. Although the color temperature of ordinary household tungsten lamps varies considerably, it is generally lower than that of photo lamps, so that the use of an 80A will not produce technically accurate colors, but will produce a slightly warm color which many photographers find pleasing.

Skylight 1A and 1B: These filters are essentially the same as UV filters except that they have a slight red coloring added. Many people prefer the slightly warmer rendition produced with these filters. The 1B has more of a red tint than the 1A. Singh-Ray makes a specialized set of Skylight filters which are specifically balanced to the color sensitivity character-istics of the film, and thus offer a Skylight for Kodachrome and a separate Skylight for Ektachrome type films. I have found that these filters are much superior to ordinary Skylight filters for my photography.

The 81 series: These are warming filters, available in a variety of intensities. I have found these useful when shooting Ektachrome films in open shade where these films have had a tendency to produce an overall blue cast. I have also found them useful for adding a warm glow to the subject's skin when shooting with studio flash.

Filters for both Black and White and Color Photography

Polarizing filters: If there is one filter which every photographer ought to have, it is the polarizing filter. It is a uniquely useful filter for many types of photography. Natural daylight and light from most sources is unpolarized, that is the light is travelling in waves which are oriented in all axes. A polarizing filter lets pass only the light waves oriented in a specific direction, thus polarizing the light. The polarizing filter is mounted in a rotating ring so that the axis of polarization may be controlled by the photographer to achieve the desired effect.

Many forms of natural light are polarized, and we may use a polarizing filter to either emphasize or de-emphasize them. The most common example is reflections, which are partially or totally polarized when reflected. By looking through the camera and rotating the polarizer, the photographer can eliminate reflections totally, or simply tune them to produce a desired effect. Unfortunately, this will not work on reflections from polished metal, since they are not polarized in the process of reflection, but reflections from glass, water and most other surfaces are polarized and can be controlled.

Also, most atmospheric haze is polarized, and we can use the polarizer to cut down or eliminate this haze. For color photography this provides somewhat the same effect as is achieved with yellow and orange filters in black and white photography. Reducing the polarized haze and glare intensifies the blue of the sky when the axis of the polarizer is at the proper angle to the sun. The greater the angle, the greater the effect.

There are two types of polarizers, the linear and the circular. Linear polarizers can be used with all Hasselblad cameras with the exception of the 205TCC, and will produce the greatest degree of polarization effect. Because the semi- silvered central portion of the 205TCC mirror polarizes the light which passes through it to the light meter cell, a linear polarizer will interfere with the operation of the light meter and produce incorrect readings. Only the circular polarizer may be used with the 205TCC for correct metering.

Special Types of Filters

All of the above types of filters might be used in general photography, and an assortment of them is kept on hand at all times by most serious photographers. However, there are other filters which are of less general use, but which produce effects which may be required at times.

Fog filters are intended to duplicate the effect of a foggy day. They have an overall softening effect, and also reduce color saturation. They come in various strengths for different degrees of effect.

There are also special fog filters called **Double Fog filters** which are intended to produce a more realistic effect, tending to reproduce the

Seascape by Chet Szymecki

This wonderful image is the result of two different techniques. The original black and white print is a bas-relief, an image made by sandwiching together a negative and a film positibe, slightly out of register. The black and white print has then been hand coloured in the lips and eyes to produce a very striking effect. (Photo by Lightscapes).

effect of natural fog by lowering contrast and producing flare. Under overcast light they can produce results practically identical to natural fog.

Low contrast filters are intended to lower the contrast of the image without reducing color saturation or sharpness, and are intended for photography in very contrasty light. They perform somewhat the same function as fill flash, but without the often artificial look this produces. Basically they lighten shadows.

Soft contrast filters are just the reverse. Their purpose is to leave the shadows as they are, and bring down the intensity of the highlights. Both types of filters intend to bring the contrast range of a subject or scene within the range the film can record, they just do it in opposite ways. Both are worth having on hand for very contrasty lighting.

Diffusion filters are somewhat like fog filters, but produce an overall softening of detail. These are available from a variety of suppliers, but perhaps the best are the Zeiss Softars which are available from Hasselblad in bayonet mounts. Softars use molded-in dimples on the surface of an otherwise transparent and optically neutral filter to focus secondary images over top of the overall sharp image produced by the lens. I have experimented with many different diffusion and soft focus filters, and have found the Softars among the most useful.

Mesh net filters come down to us from the high days of Hollywood. To glamourize movie actresses and to de-emphasize blemishes and wrinkles, cinematographers took to stretching silk mesh across the front of the camera lens. Legend has it that the first of these was from a pair of the actress's hose. Today you can buy fancy filters with various types and colors of mesh sandwiched between glass, or you can stretch mesh fabrics across your lens and experiment. Black netting reduces surface detail without greatly degrading apparent sharpness, white will lighten shadows and bring down harsh lighting, while colored fabrics will impart a hint of their color as well as softening the details.

Graduated neutral density filters - one of the greatest inventions in photography. How often has the photographer spent hours in the darkroom burning and dodging to get the tonal range of a negative onto the print? When the sky is too bright, or when any other part of the image is much brighter than the rest, the graduated neutral density filter is the life saver. These filters are available in a variety of sizes and in both plastic and glass, and generally fit into a holder which bayonets onto the lens. Now filter makers offer us not only the original neutral density types, but

a variety of colors as well. That dull gray sky can now be vibrant blue, or the pink of a rosy sunset.

Color enhancing filters have the ability to accentuate certain colors in a scene without having a noticeable effect on the other colors. They are useful particularly in advertising photography.

Of course there are many other types of filters, and more coming on the market every day. You may personally like the effect produced by the star or starburst filters, which I find objectionably over-used. Filter makers such as Cokin, Tiffin, Jessop, and others offer a wide variety of types and usually have full descriptive literature available.

Vignetters are related to filters and are used in some types of photography. These are used to soften parts of a scene or darken parts without effecting others. Vignetters are normally made from clear or colored plastic sheet and may be used with the professional lens shades or with specialized vignetter holders from a number of manufacturers. I have always been happiest making my own from a variety of transparent and translucent materials, most of which are readily available at art supply, hobby and crafts shops.

The important thing to remember when using vignetters is not to overdo the effect. It should not be obvious to the average viewer that a vignetter was used. When used properly, particularly in portraiture, vignetters can produce beautiful effects.

When using a white vignetter to remove a background, it is often a problem to get enough light onto the vignetter so that it will photograph white and not gray or dingy brown. A simple solution to this is to mount a small electronic flash unit (it need not have much power) so that it fires at an angle to the vignetter, striking its surface. A number of firms make articulated and flexible arms which can easily support such a small flash and allow it to be adjusted to the proper angle. The articulated arm can be attached to the camera stand or tripod, or can even be attached to the camera or grip for a hand-held setup.

Fashion shot by Lightscapes

CF lenses		Ø 26	Ø 50*	Ø 60	Ø 63*	Ø 70	Ø 86*	Ø 93	Ø 104*
					Filter diameter				
30mm Distagon CF		◯							
38mm Biogon CF (903SWC)				◯	◎ 51638	◎ 40714			
40mm Distagon CF (FLE)								◯	
50mm Distagon CF; 50mm Distagon (FLE)				◯	◎ 51638	◎ 40714			
60mm Distagon CF				◯	◎ 51638	◎ 40714			
80mm Planar CF				◯	◎ 51638	◎ 40714			
100mm Planar CF				◯	◎ 51638	◎ 40714			
105mm UV-Sonnar CF				◯	◎ 51638	◎ 40714			
120mm Makro-Planar CF				◯	◎ 51638	◎ 40714			
135mm Makro-Planar CF				◯	◎ 51638	◎ 40714			
150mm Sonnar CF				◯	◎ 51638	◎ 40714			
250mm Sonnar CF				◯	◎ 51638	◎ 40714			
250mm Sa Sonnar CF				◯	◎ 51638	◎ 40714			
350mm Tele-Tessar CF							(◌)*	◯	
500mm Tele-Apotessar CF							(◌)*	◯	
140–280mm Variogon CF								◯	

* These items are no longer manufactured

Hasselblad Original Filter Guide

On the edge of each filter, there are engraved designations indicating diameter, filter factor, and exposure value reduction (EV). In some instances the Kodak Wratten designation is also given. With one exception, the Hasselblad CF lenses only require two filter diameters. Step-up rings make it possible to use large diameter filters with lenses that have smaller accessory mounts. The large circles indicate the right filter diameter for each lens. The double-rings indicate a filter diameter that can be used in conjunction with a step-up ring or ring/lens shade. In such instances, the product number is also given. A dotted circle indicates that a discontinued filter diameter fits.

F lenses

Lens	Ø26	Ø50*	Ø60	Ø63*	Ø70	Ø86*	Ø93	Ø104*
50mm Distagon F (FLE)							O* (40706)	
80mm Planar F*		O*	O (40711)	O* (40053)				
110mm Planar F					O			
150mm Sonnar F					O			
250mm Tele-Tessar F					O			

C lenses*

Lens	Ø26	Ø50*	Ø60	Ø63*	Ø70	Ø86*	Ø93	Ø104*
30mm Distagon C*	O							
38mm Biogon C (SWC/M)*				O*				
40mm Distagon C*								O*
50mm Distagon C*				O*				
60mm Distagon C*				O*				
80mm Planar C*		O	O (40711)	O* (40053)				
100mm Planar C*		O	O (40711)	O* (40053)				
105mm UV-Sonnar C*		O	O (40711)	O* (40053)				
120mm S-Planar C*		O	O (40711)	O* (40053)				
135mm S-Planar C*		O	O (40711)	O* (40053)				
150mm Sonnar C*		O	O (40711)	O* (40053)				
250mm Sonnar C*		O	O (40711)	O* (40053)				
250mm Sa Sonnar C*		O	O (40711)	O* (40053)				
350mm Tele-Tessar C*						O*	O (40703)	
500mm Tele-Tessar C*						O*	O (40703)	

* These items are no longer manufactured

Hasselblad Original Filter Guide

8: Flash Photography with the Hasselblad

Today the bulk of photographs taken with artificial light are taken with electronic flash. The ability to pack a powerful, short-duration burst of light into a small and portable accessory revolutionized photography. The color temperature of electronic flash is normally about 5000°K - approximately the same as daylight at mid-day. Although some photographers still use flash bulbs for specialized types of photography, their use has declined dramatically. Those who have need for this specialized lighting can obtain information from the flash bulb manufacturers.

You may wonder why I insist on referring to these devices as electronic flash units or simply flash instead of the commonly- heard "strobe". This is because, in spite of its prevalence, "strobe" is not a synonym for electronic flash. "Strobe" is a shortened form of stroboscope, and refers to an electronic flash unit of particular type which flashes repeatedly at adjustable intervals. Such specialized flash units are used for studies of motion and have been popular in the past in discotheques, but have rare use in general photography. Let's stick with calling an electronic flash unit a flash and calling a stroboscope a "strobe".

With an electronic flash unit the proper exposure must be determined by the Guide Number method, or with a special light meter which can read the short-duration bursts of light produced by electronic flash. When using only a single flash head, the Guide number method is relatively simple.

The Guide Number of a flash unit is simply the lens aperture for proper exposure multiplied by the distance. As an example, a flash unit with a stated Guide Number of 160 would require an aperture of f/16 at a distance of 10 feet. In use the photographer either measures the distance to the subject, estimates the distance, or reads the distance from the focusing scale on the camera lens, and divides that number into the Guide Number to arrive at the proper aperture for exposure at that distance.

However, there are problems with this system, so it is imperative that the photographer perform a series of tests before trusting this method for

Informal portraiture should be exciting, attractive, even glamorous. Here photographer Barry Hayes has produced a very dynamic image with simple lighting and background.

important photos. The first problem is that the stated Guide Numbers provided by flash manufacturers may be overly optimistic, or may simply have been determined in ideal surroundings rather than the real surroundings encountered by the photographer. Guide Numbers will be affected by the surroundings, increasing when the photography is done in reflective surroundings and decreasing when the photography is done in non-reflective surroundings. A flash which produces an accurate Guide Number of 160 in a small room with white walls will have a much lower effective Guide Number outdoors at night. Rather than relying on published Guide Numbers, the photographer must make film tests to determine what the working Guide Numbers of the flash equipment really are.

The second problem encountered with the Guide Number method is when working with multiple flash. Guide Numbers can be used to figure out exposure in such situations, but the math can become complicated. As an example, if you are using two flash units, each with Guide Numbers of 160, and each at ten feet from the subject, the proper exposure would be f/22 for areas of the subject illuminated by both flash units. However, if the flash units were placed at distances of ten feet, but on either side of the subject, the aperture would then be f/16, because any area of the subject is illuminated by the light of only one flash. If the flash units are set to different distances, and only partially overlap in coverage, it begins to get complicated. For this reason, for multiple flash setups, I recommend using an accurate flash meter.

If you do decide to use the Guide Number method for computing proper flash exposure, be certain that you know whether the guide number for the flash is stated as a metric or English Guide Number. They appear in both forms in flash literature, and, of course, are not interchangeable even though they work the same way. With a metric Guide Number you divide by the distance in meters to arrive at the proper aperture.

When using studio flash, the most common method of firing the flash is with a synchronizing cord connecting the flash to the camera. When the camera is fired a switch in the shutter mechanism fires the flash at the instant when the shutter is fully open. With leaf shutters such as used in the C and CF Hasselblad lenses this can be achieved at any shutter speed. Due to the nature of leaf shutters, they must open fully every time they are fired, regardless of the shutter speed. However, the focal plane shutters used in the 1600F, 1000F, 2000 series and the 205TCC cameras

are quite different. At higher speeds they do not open fully, the exposure is made by a travelling slit which passes across the film. Hasselblad shutters move across the film plane horizontally, and the fastest speed at which they fully open is 1/90 second in the 2000 series and the 205TCC, 1/30 second in the 1600F and 1000F. If the camera were set to a faster speed during a flash exposure, only a small portion of the image would be recorded and the rest of the frame would be blank. For this reason, on the 2000 series and 205TCC, if the shutter is set to a speed faster than 1/90 second the flash will not fire. This is to serve as a warning of improper synch.

I should mention, because it has confused some photographers new to the system, that the early 500C and 500EL cameras (built prior to 1976) have a PC flash synch socket on the left side of the camera body below the accessory attachment rail. This PC socket is never to be used when shooting flash photos with the C and CF lenses. Whenever these lenses are used, the flash synch cord is plugged into the PC outlet on the lens itself. This secondary PC outlet on the camera body is connected to a switch activated by the secondary blind in the camera body. It may be used to fire a flash in a darkened room when non-shuttered lenses or accessories are specially adapted to the 500C and 500EL cameras. Since this feature was so seldom used, and since the secondary PC socket confused some photographers and made them lose photos, this was omitted from later 500C and 500EL bodies.

In cases where an unusual lens or accessory must be attached to a 500 series body, Hasselblad offers a microscope shutter, which is basically the shutter used in the lenses mounted into a blank barrel. In operation it is identical to any of the C lenses, and may be used to adapt anything which does not require a larger than 25mm barrel diameter. However, it does not have any focusing mount of its own, so for focusing it must be used with the bellows unit or variable extension tube.

STUDIO FLASH

It is beyond the scope of this book to examine studio flash lighting in depth, there are many good books on the subject which can be referred to for more details, but I must mention it because the Hasselblad is ideally suited to studio work.

Basically there are two types of studio flash systems on sale today; the very popular one-piece, monolight types and the more traditional power pack with separate heads. Both have their proponents, both have their important features, and both are viable choices for the studio photographer.

The one-piece units have the power supply, associated electronics and the flash head all built into a compact body. This is a very good design for general studio use and great for portable location shooting. The size of these units has decreased and the light output has increased as improvements have been made in the designs and the capabilities of the electronics, but there is still an upper limit to the amount of light output possible from such units. If your photography is done in small to medium sized studios with medium speed films, these units should be perfectly adequate, and, indeed, I have found them so myself and use this type of unit in my studio at the present time. I am particularly pleased with some of the most recent designs which pack a lot of light into a small package, recycle quickly, and feature such design niceties as continuously variable light output.

However, when you really need a lot of light, for big studio sets with slow film you may find that only the big power packs with separate heads will do. These offer a variety of design options, with plenty of power available for the big jobs, and such things as fan-cooled heads for rapid repetitive shooting.

When shopping for studio flash today, there is one feature which I would absolutely demand, variable light output. Most units have full and half-power settings, some offer quarter power as well, but you may find, as I have, that this is often frustrating. Once you have the lights placed exactly as you want them, lack of graduated power control means that you must move the lights themselves toward or away from the subject to fine tune the exposure, and that disrupts the quality of light you have so carefully set up. Several brands of lighting equipment now offer full-range continuous light output control, and I find it essential for fine light control.

While the range of accessories for studio flash does vary from brand to brand, and a number of independent suppliers offer accessories to fit most brands, several types of accessories are common to all and worth a brief description.

Perhaps the most common and most versatile type of light, which has gained broad acceptance in recent years, is the softlight or softbox. These

Today's fashion photography often uses direct, rather hard light to achieve its effect. (Photo by Robert Ruymen).

are, typically, large rectangular or square reflector/diffuser units which attach to the front of the flash head. Sometimes they are referred to in the trade as "fish fryers" because of their shape. While the early ones were very heavy and made from sheet metal or fibreglass, the most common ones today are made from fabric which forms a sort of "tent" supported by lightweight ribs. I have been using this type myself for some time now, and am very pleased with the control it affords over the light. The particular softbox which I favor is the Multidome made by Photoflex. I like this particular model because it is light in weight, folds quickly and easily for portability or storage, can be adapted to practically any brand and type of flash with a simple adapter, and features removeable internal baffles and Velcro reflective panels which allow an almost infinite control of the quality of the light. Because each of the four sides of the lightbox is fitted with a separate reflective panel, these can be individually altered by simply zipping the Velcro edged panels in or out. This gives the choice of white, silver or gold for each panel, and any mix of the three may be used for specific lighting effects. Additionally, the internal baffle may be removed or fitted and the front diffusion panel may be used or removed, or fitted at several different positions, again affording maximum light control.

An important point to remember when working with soft light is that, regardless of the type of light, the closer the light is to the subject the softer the light will be. This is because any light, as the distance increases, begins to assume the character of a point source, the hardest, harshest type of light. It makes no sense to use large softboxes to soften the light and then locate them twenty or more feet from the subject. You might as well use ordinary reflectors, and save the light loss caused by the diffusion.

Reflectors are generally dish-shaped bowls used to focus the light to varying degrees. The effect they produce is controlled by their shape, which may be more or less parabolic to produce a beam of light, and by their internal finish, ranging from shiny polished metal, through textured metal to dull white.

The beam of light projected by the reflectors may also be further controlled by broad flaps, called barn doors, which clip to the reflector bowl and can be moved into position to block parts of the beam of light. The beam may be brought to greater focus by means of grids attached to the front of the reflector, either large open grids or smaller honeycomb grids for greater effect, or may be focused even more by adding a snoot.

For those times when a truly focused beam is needed, fresnel lenses or optical lenses may be used, perhaps to throw patterns on the subject.

Whatever sort of studio lights and reflectors you settle on, don't scrimp when purchasing the stands to support them. Sturdy, professional stands will cost a bit more at the outset, but will more than pay for themselves by saving lights from falls to the floor. How tall the stands need to be will depend on your likely requirements, but I have always made it a point to have at least a couple of twelve-foot stands on hand for those occasions in which a high light angle is desired. Similarly, you will want to have at least one backlight stand which can be set very low.

If you are installing a permanent studio, you may want to investigate one of the studio ceiling rail systems which bypasses the need for lightstands altogether and suspends the light from pantographs attached to dollies which ride on rails suspended from the ceiling. I know many photographers who use these systems with complete satisfaction.

I have found that the best way to learn studio lighting is to acquire a relatively complete set and then spend some time working with the various parts of the kit to visually determine what they do. A great aid in learning lighting is a Polaroid film magazine which allows fixing the impression created by a certain lighting setup, and gives a permanent reference to compare against changes. You may wish to use the broader border or the back of the print to make a rough lighting diagram and then keep a file of Polaroid prints as a lighting reference library. Because it may be difficult to find a model patient enough to put up with you through all of these tests, you may wish to buy a mannequin. These are available from photographic suppliers as a head and shoulders mannequin made from styropor or other inexpensive plastic, or you may wish to look for a used department store mannequin at rummage sales. Several years ago I bought some full-length mannequins from a lingerie store which had had a fire, and after repainting with flat latex paint in an approximate flesh tone they have functioned very well for testing new lighting setups.

PORTABLE FLASH

For weddings, sports, nature and general action photography we need a portable flash. Portable flash units come in three basic types, the manual units, the automatic units and the dedicated units. Manual units

are used in much the same manner as studio flash equipment, with the exposure determined from the Guide Number or with a flash meter. Some of these have variable power settings for greater flexibility, but they are simple units at heart.

The first advance above these simple units came with the introduction in the late 1960s of automatic flash units. These units are fitted with a sensor which responds to the flash light reflected back from the subject and quenches or shuts off the flash tube during the discharge when sufficient light has reached the subject. Such units can produce very accurate exposures of subjects of average reflectance.

The natural next stage of flash evolution was TTL OTF automatic flash, the system used by most advanced cameras today. In a TTL OTF (Through The Lens, Off The Film) automatic system, the sensor is placed inside the camera, usually in the front or side of the reflex mirror box, and points back at the film. It responds to light reflected from the surface of the film during the actual exposure, and is generally quite accurate. Because it senses the light reflected from the film surface after passing through the lens, it is not affected by changing lenses. In all cases it reads the same central area of the film, so its effective measuring angle changes with the angle of view of the lens.

Such systems also have the virtue of not requiring exposure compensation for such things as bellows, extension tubes, filters and such, because the light measured by the sensor has already passed through those accessories. This has greatly simplified exposure determination in close-up photography, in particular, but has also been a boon for photography in general.

As with all metering systems, however, there are important things to remember. The sensor reads light reflected from the center of the image during exposure, so it has a definite measuring angle. Like all meters it is programmed to assume a subject of 18% reflectance, and can be fooled by light or dark subjects. Additionally, since it measures the light reflected from the surface of the film, it must be optimized for an "average reflectance" film, and using unusual films or new films with different reflectance can cause exposure errors.

In spite of all these caveats, the systems do work, and work well for most subjects and most films. I have used a number of such TTL flash systems and have been very pleased with the results.

These systems are particularly agile at balancing fill flash with ambient light, particularly when used with an automatic exposure camera such

at the 205TCC. However, even with the non- automaic exposure cameras, the process is greatly simplified.

Hasselblad has incorporated the sensor and circuitry for an advanced TTL system into all current cameras except for the Superwide, where the rear of the lens comes too close to the film and would block any sensor. All of these have been designed for compatibility with the SCA system devised by European flash manufacturers.

To operate an SCA flash system with a compatible Hasselblad camera, the SCA 390 adapter for the flash in use is needed. There are two cables which come from this adapter and attach to the camera, one ending in a multiple-pin DIN type plug fits into the side of the camera, the other ending in a PC contact fits into the lens (except on the 205TCC, in which case the PC connection is not necessary, the flash synchronization being accomplished through the main plug. However, since the dangling cord may get in the way or snag on something, it is best to plug it into the PC socket on the side of the camera body to keep it out of the way. Of course this only applies when using the focal plane shutter in the camera body; when using the lens shutter the PC cord is always plugged into the PC socket on the lens itself). In the case of shoe mounted flash units, the flash unit fits directly onto the SCA 390 adapter. For use with handle mounted units, the SCA 300 adapter is attached to the SCA 390 adapter, and the cable from the SCA 300 is attached to the flash. This sounds more complicated than it is, and works quite easily.

The Metz 45 CT5 and 60 CT2 require the SCA 590 adapter, which is a one-piece unit requiring no other accessories for connecting the flash to the camera. Operation is otherwise the same as with the SCA 390/300.

Once the flash and SCA adapter(s) are connected, operation of the flash is very simple. The camera body ISO index must be set to the proper ISO for the film in use (on the 205TCC this is done automatically when the film magazine is set for the correct ISO, and must be programmed into the body when using film magazines without the ISO dial). Once the flash is switched on, you can tell when it is ready to fire because it will cause a red LED to the left of the camera's focusing screen to light (this will appear on the right when using the prism finders). The camera is then fired normally, and the same red LED will blink momentarily to indicate that exposure was sufficient. However, this system only indicates if there was sufficient light, it does not have any facility for indicating too much light, so in situations where this is possible I would recommend film tests.

When using the SCA flash system for fill flash, it is possible to create a variety of effects by altering the ISO setting. For example, if you want to decrease the amount of fill flash, you simply set the ISO dial to a higher number than the actual ISO of the film (this, however, can not be done with the 205TCC when used in the camera's auto exposure modes because the same ISO control sets both the camera's metering and the flash sensor's sensitivity).

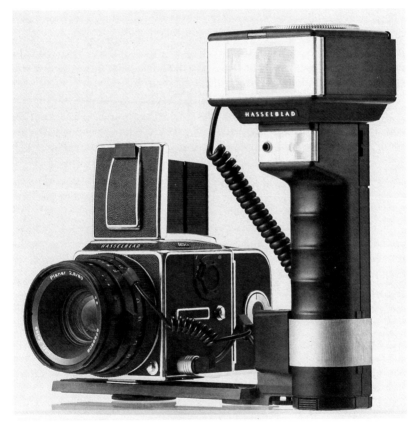

Hasselblad Proflash 4504 for 503CX, 500ELX, 553ELX and 205TCC

Hasselblad have recently introduced a handle-mount flashgun under their own brand name. This flash is built for them by Metz and is essentially identical to the Metz 45CT4 unit except that the circuitry from

the SCA modules has been incorporated into the flash itself. This simplifies operation, since only a connecting cord from flash to camera is needed for fully dedicated operation, and this cord is supplied with the flash. I would recommend this flash, however, only to the photographer who uses Hasselblad cameras exclusively. Unlike the Metz units, it is not easily adaptable to other cameras, and the photographer who uses multiple systems may not want a flash usable with only one system.

When using camera-mounted flash I have often found that the light when the head is directed at the subject is too harsh. A variety of different schemes for somewhat softening the light have appeared at times, some in which the flash head is turned upward and the light bounced off a reflective surface and some in which the flash head is pointed backwards and reflected off a small umbrella. I have used many of these with varying degrees of success, but recently I have been using what I feel to be the ideal solution to this problem. This is the Inflatable XTC Softbox from Photoflex. This is a small softbox, working in theory just like their larger ones, but instead of being supported by a rigid frame this one is supported by air. It is made entirely from high quality vinyl and can be inflated or deflated by the photographer in a matter of seconds, and weighs well under an ounce. The Inflatable XTC is attached to the flash head with Velcro, for quick and easy attachment and removal, and comes in two sizes which can fit practically any brand of accessory flash. Since the unit is inexpensive, as well, I give it my highest recommendation. Since it became available, all of my camera-mounted flash units have been fitted with them and I have taken no photographs without them. They are particularly good for diffusing outdoor fill flash.

MOUNTING ON-CAMERA FLASH

Hasselblad has offered a number of options for mounting of flash units used on-camera. For small, lightweight units there is an accessory shoe which can be clipped to the front of the square lens hoods. The PM and PME series of prism viewfinders have a flash shoe on top for direct mounting of small to medium sized flash units. There is also an adjustable flash shoe which mounts to the side rail of 500 series cameras and accepts a flash directly.

For those times when the flash is to be mounted near the camera, the Hasselblad side mounted hand grips have always had a flash shoe on

top. This is sturdy enough to accept even the heaviest shoe mounted flash unit. A number of accessories have been offered to allow mounting of the flash in a position directly over the lens.

Quick Release Adapter for Hasselblad flashgun brackets (numbers 45071, 45072, 46329 and 46330) to allow them to be mounted on the Hasselblad Tripod Quick Coupling

Just at press time Hasselblad has introduced a new accessory for their handgrips, the Quick Release Adapter. This clamps onto the handgrip's lower section and provides a quick release foot similar to that on the bottom of the camera bodies, so that the camera with grip and flash may be quickly attached to and removed from a tripod or other support. It mates with the standard Hasselblad Tripod Quick Coupling, which has been available for direct use with the cameras for many years.

Additionally, other suppliers have offered flash brackets compatible with or specially built for the Hasselblad system.

The well-known American photographer Denis Reggie has used the Hasselblad system for years to produce his excellent photographs. Experience led him to design and perfect his own flash support bracket, since none of the ones commercially available fully suited his needs. The Reggie Bracket for Hasselblad has just become available as this book is being written.

Basically, the Reggie bracket is a very strong metal U- shaped bracket, which supports the camera on one arm of the sideways U and the flash on the other. To make the bracket comfortable in use, the handle section is padded with high- quality foam, which also adds to the comfort of prolonged shooting sessions. The eliptical shape of the handle conforms to the hand for comfort, and the fact that it is hollow reduces the weight of the bracket. The entire bracket, fitted with the adapter for Metz handle-mount flash, weighs only twelve ounces. In spite of this light weight, it is very strong due to the construction from aircraft aluminium.

In use this bracket positions the flash either directly over the camera lens, or slightly at the left at the photographer's choice, for ideal light

Reggie Flash Bracket for Hasselblad

placement. The support arm which holds the flash has two positions, one for distances of 25 to 30 feet and more, and with the flash at a greater downward angle for shooting at the 10 foot range. By means of a series of adapters, practically any brand or type of flash unit may be mounted. I did my own testing with the Metz 45CT-4, and found the balance of the system practically perfect, and

the light angle ideal for most shooting. While not normally supplied with a cable release, for those who prefer to trigger the camera with their left hand a cable release and fitting are available as an option.

The bottom plate of the Reggie bracket is grooved so that the Hasselblad camera bottom plate is locked into place when tightened down and cannot rotate on the plate. Additionally, the bottom plate of the bracket is formed so that it fits directly into the Stroboframe 300-ORC Quick Release mounting clamp without adapter.

The Stroboframe 300-ORC Camera Auto Quick Release is a newly

Denis Reggie with new Reggie Bracket for Hasselblad and Metz Flash Mount

devised quick release system which overcomes most of the failings of previous systems. The system is in two parts, a camera plate, available in different configurations for different types of cameras (and, as I said above, unnecessary with the Reggie bracket) and the tripod clamp, which can attach to any tripod with 1/4 inch thread. Once the plate has been attached to the camera and the clamp to the tripod, the two are joined by simply fitting the front of the plate into the clamp jaw and pressing down into place. It is totally self-locking, and quite secure. To remove the

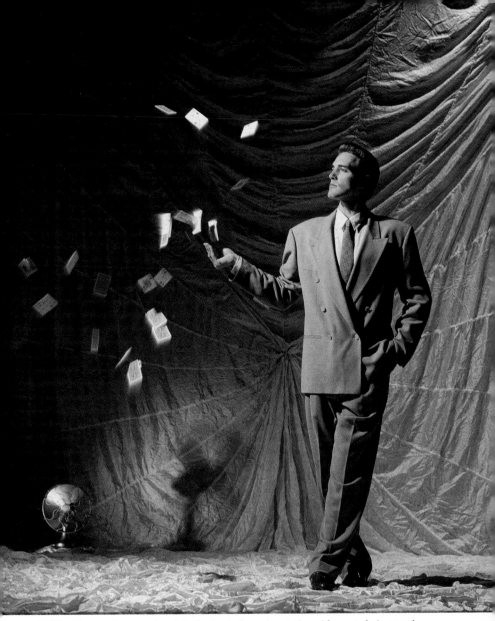

Fashion photographers are often at the forefront of experimentation with new techniques and ideas. This golden image was taken with an old parachute as the background, with colored gels on the lights to produce the golden glow. (Photo by Lightscapes).

camera, simply press in the release arm on the clamp and the camera plate comes free. It is the simplest to use and best designed quick release that I have seen, because it is truly quick. Many so-called quick release systems take nearly as much time and trouble as simply screwing the camera onto the tripod.

Another very nice flash bracket which works well with the Hasselblad is the SQ 2000 Stroboframe bracket. This is made from the same materials as the Reggie bracket described above, but is adaptable to many different medium format cameras with the addition of specific anti-twist plates. When used with the Hasselblad anti-twist plate the camera is held rigidly in place. The flash is supported on an arm which can be moved to three different angles, and the arm is removeable and can be replaced with an accessory longer arm for greater flash elevation when required. The hand grip is also adjustable to a variety of angles for

personal comfort and is made from oak, as is the palm pad which allows extra stability in supporting the grip with two hands. A cable release and fitting are standard equipment on this grip. Although I have not personally tested the SQ 2000, I have used the companion RL 2000 which is designed for larger 35 mm equipment with great success.

MACRO FLASH

Hasselblad Macro Flash Unit

For some time now, Hasselblad has offered a specialized macro flash system which replaced the earlier ring flash units formerly used for much macro work. The Hasselblad Macro Flash Unit is built for Hasselblad by a major European flash manufacturer, and is a state-of-the-art, TTL dedicated system for simple macro flash photography.

This fashion photo of swimsuited models works so well because of the careful posing of the three models. Furthermore, the square format is perfect for the composition. (Photo by James DiVitale).

The system consists of a power pack with SCA adapter which may be mounted atop the prism finders or beside the camera on a special support arm. This power pack connects to and powers two small flash heads which mount on a support bracket through articulated arms. These arms allow the direction and relative placement of the two heads to be varied. The support bracket attaches to the front of the lens in use by means of an adapter.

The two flash heads are connected to a distributor unit which normally mounts atop the support bracket and sends equal amounts of energy to each flash head. A switch on this distributor allows switching one of the

Landscape by Robert Jay Haber.

heads off when desired, and also has the flash test button for test firing of the heads.

For times when as greater lighting ratio is desired between the two heads, a neutral density gray filter is supplied for attaching to one of the heads.

In addition to TTL operation, the Macro Flash Unit may also be set for manual control with incremental power adjustmsnts down to 1/16th power. For the photographer who uses more than one camera system, the Macroblitz can be adapted for TTL operation with any camera for which SCA adapters are available. This means that the photographer can shoot medium format macro work with the Hasselblad and by simply switching the SCA adapter, he can also use the same system on most modern 35mm cameras as well.

9: Why the Square Format?

Ever since man began to draw and paint, the vast majority of art has been created in the rectangular format. The ancient Greeks codified the perception of this rectangle and created the ideal format, the golden rectangle, which has the proportions of 1 to 1.27. Today we find everything from magazine pages to credit cards designed with these proportions, the proportions considered most pleasing to the eye.

Modern cameras are designed to produce a variety of standard image formats ranging from the relatively long rectangle of the standard 35mm frame and the 6x9 medium format frame (proportions of 1 to 1.5) to the square format used by Hasselblad and some others. Today we see cameras offering 6x9, 6x8, 6x7, and 6x4.5; but since its inception the Hasselblad camera has been designed around the 6x6 square.

One reason for this is tradition, when Victor Hasselblad was working on his first cameras a large number of square-format cameras were on the market, not the least of which was the highly successful Rolleiflex twin-lens reflex. Many professionals had standardized on the 6x6 format and would have been unlikely to adopt a camera with a radically different format. The second, and more important, reason for the square format was practicality.

Every commercial photographer has encountered an art director or client who has changed his or her mind after a job has already been shot. Sometimes these changes are unimportant, sometimes they require a re-shoot. However, if the original shoot has been done on a square-format camera the change of mind from horizontal to vertical composition requires only a re- masking of the images.

Recently we have seen major growth in the 6x4.5 or 645 format, considered the "ideal format" by some. Hasselblad has listened to the demands for this size and produced both the standard 645 magazine and the special vertical one.

In the past, people involved in the visual arts were given training which encouraged their innate sense of design. This sense of design allowed an art director to view a square transparency or print and visualize the two different basic rectangular compositions contained within. Skilled people like this would spend hours with the print or transparency and a set

of cropping L's working to determine exactly the composition which best expressed the concept of the job.

Today we are finding more and more untrained eyes in the position of art director or creative director. These people require that the photographer deliver the job in the exact rectangular format for final use. For this reason, photographers have begun to use the rectangular 645 and 6x7 formats more and more and to abandon the square format. As a Hasselblad photographer, if you find yourself working with people who cannot look at a photograph and visualize the varying possible compositions within, I suggest that you acquire one or more 645 backs and begin to shoot in this format. Otherwise shoot in 6x6 and mask the transparencies or prints to rectangular proportions before delivering the job.

That being said, there is much to recommend the square format itself as a compositional tool. There are times when the best possible composition can only be square. In advertising, shooting the photographic portion in square format leaves room on the rectangular page for ad copy which does not intrude on the image. There is a special openness, a particular spatial quality, to a properly composed square image which can never be duplicated in the rectangle. The square composition requires a level of seeing, a sense of proportion and perspective, which is more difficult to master.

In 1976 Michael Gnade wrote a slim book for Hasselblad entitled *Square Composition* (unfortunately no longer in print) in which he addressed the subject in some detail. One quote in particular struck me, " At the start of my career, I worked exclusively with a 35mm camera and with the rectangular format's horizontal or vertical field. But I remember the first time I used a 2 1/4 x 2 1/4 camera. The experience was like being thunderstruck, and I really savored the image revealed in the viewfinder. That format enabled me to 'see' the subject for the first time."

What Gnade saw was the enhanced visual potential of his subjects as reflected in the square frame. He began to see the square frame itself as an important visual element, like a large square window through which the world is viewed. Not only is the square window more of a challange than the rectangle of 35mm, the larger viewfinder image allows the photographer to feel closer to the subject, it is a more intimate view.

By being square, the format imposes no preconceptions on our composition, it, at the same time, frees us and places a heavier burdon on us as photographers. Since we see about the same amount of horizontal and vertical in our natural visual field, the square format could be said to be a more "natural" format.

The Standard Focusing Hood of the Hasselblad makes it an ideal instrument for composing interior shots using wide-angle lenses. Photo by Dennis Lee.

All of that being said, you may ask why, then, are the vast majority of the images in this book printed to rectangular proportions. Partly this is due to a desire to utilize the page to its maximum by filling it with the image, and partly it is due to the conventions of today, we expect to see rectangular images. In most cases the photographers themselves cropped the images to rectangular format prior to submission. We live in a world in which the rectangular image has been pushed upon us, but that is no reason for the Hasselblad photographer to submit to convention. You may find that your own personal world view is best expressed in the square format.

If this is the case, most of the processing labs will be able to accomodate you if you explain that you really do want square prints. In most cases you will have to pay for the next larger rectangular size because the paper is supplied that way. Thus the Hasselblad photographer may request an 8x8 inch image instead of the common 8x10, or an 11x11 instead of an 11x14.

If you do your own darkroom work, you may elect to trim the photo paper into square size and use the extra for test strips, which are always needed and generally created at the sacrifice of an entire sheet of paper, or you may prefer to leave an extra-wide border on one side of the print and use this as a space in which to record data about the image. Some photographers leave the wider border at the bottom of the print and write short text or poetry to accompany the image. If you do decide to write in this wide print margin, use a good quality artist's permanent ink to ensure that the written text has stability equivalent to the photographic image.

COMPOSITION

Whole books have been written about photographic compositon, but regardless of what is written one point cannot be avoided. Some people have an innate sense of composition which can be honed by practice, while others have little or none and must work hard to develop enough of a sense of composition to function as photographers. I know many top level photographers, and it is often surprising to me to find out how many of them started out as painters or came up through a traditional fine arts training. This sort of training can be invaluable, particularly a detailed study of the old masters of painting and sculpture, as it tends to load the principles of composition into the unconscious mind, so that they are used in photography without being consciously thought about.

Those photographers with no fine arts training can make amends by going to the local library and checking out some books on art history and the paintings of the old masters. Particularly applicable to photography is a study of the Flemish and Dutch masters, whose works often have a "photographic" look. By studying these works, I do not mean spending hours in analysis of how and why the artist did this or that, but simply some time spent looking at the images and absorbing their sense and feel. I do not recommend conscious apeing of old masters paintings, it tends to produce stale and often ridiculous work.

Those of us who learned to read in Western cultures generally scan a photograph in the same way we scan a printed page, that is we tend to start on the left and scan across toward the right. We learn this early-on, and tend not to be aware of it unless it is pointed out to us. Additionally, we tend to start our scan toward the top, again because this is how we

would approach a printed page. It helps in composing photos to keep this in mind, although the photographer who wishes to sell photos on a worldwide basis may want to shoot some images in reversed composition.

I have sold a number of photographs through an agent in Japan, where visual scanning tends to be a combination of Eastern and Western, and have often been surprised to find that the image was flipped left to right prior to publication. I am convinced that cultural bias has much more of an impact on our appreciation of art and photography than we are aware of, and that insufficient attention has been paid to this in general studies of psychology and art.

I have designed three drawings to make this point in simplified manner. In drawing number one, you will find that your eye tends to enter the image at the left and progress across toward the right, following the horizon line, stopping briefly at the house, and then continuing on out of the frame. A photograph composed in this form will not hold the viewer's attention unless the object placed in the location of the house is very interesting in and of itself. I have seen many, many photos composed exactly in this form, and whether they work or not is totally dependent on this internal, contextual interest. From a compositional point of view, this is a boring composition, one which does not intrinsically hold the viewer's eye.

In the second drawing, I have placed a psychological barrier at the right side. In this case it is a tree, but it can be anything, even a negative element. The point is that it disrupts the tendency of the eye to pass rapidly across and right out of the frame, dismissing the photo. The track

Framing a composition designed on divisions of a 1:1 ration image. Top: *where no foreground is available, a 2:1 positioning of the horizon and the major element in the composition produces an attractive balance.* Centre: *introducing a framing foreground element on the 'near' side of the subject fails.* Bottom: *extending the framing over the top of the picture improves the balance.*

of the eye then encounters this barrier, and like a rubber ball bounces back into the frame. However, it then tends to leave the frame through one of the other open sides unless, again, the subject at the position of the house is interesting.

In the third drawing I have added a tree branch across the top to act as a secondary psychological barrier, to deflect the eye back down into the image again. Of course, this is very simplified, and no amount of psychological barriers will save a photo that is otherwise visually dull. The point of the image should be to capture and hold the viewer's attention, not with gimmicks, but with valid visual elements which combine to make the image work as a whole.

Novice photographers tend to place the center of interest right smack in the center of the image. In viewing photographs taken by beginners and amateurs, I see this all too often. Sometimes it works, but more often it produces dull, visually static images. This tendency to place the important element(s) at dead center seems to be even worse with photographers working in the square format. I suppose the symmetry of the format tends to encourage symmetrical, balanced images, but they must be very strong to work. If you will examine the images I have picked for this book you will see that very few of them have the main subject of interest at dead center, and the few that do so have very visually active and interesting subjects.

This tendency to place the main subject at the center is unintentionally encouraged by Hasselblad, because the focusing aids, when used, are in the center. The beginner who uses a split image or microprism to assist focus tends to keep the subject centered after it has been brought to focus. The more experienced photographer will first focus on the main point with the focusing aid, and then move the camera to re-compose the image for better balance or vitality prior to taking the photo.

I generally discount the idea of "aesthetic rules". I have found that anything can work when everything is right, and filling your head with such "rules" will only prevent you from taking that spectacularly unusual image when it presents itself. However, one "rule" will often help the novice if not adhered to with too much rigidity. This is called the rule of thirds, and generally states that greater visual interest is obtained by placing points of primary interest along lines which divide the image into thirds. The drawing illustrates the image field of the Hasselblad divided into thirds both horizontally and vertically. I do not suggest drawing these lines on the focusing screen, because this is a very

Left: *division of a square format into a grid pattern which is used to identify major axes and point.* Centre: *the S-curve or line of beauty.* Right: *a pyramid or receding perspective composition.*

approximate rule, and the placement of the image should not be done by mathematical formulae or pre-drawn lines. However, if you keep this rough division into thirds in the back of your mind you will probably find, as I do, that it helps in creating images which are visually interesting.

If you were to make a detailed study of paintings of the old masters, you would see this rule of thirds over and over. They were well aware of it, and used it as a compositional aid. They also were aware of a number of other general compositional forms which can be translated to photography. The broad, sweeping S curve, for example, has applications from landscapes and scenics to group portraiture. Take a look at the simplified S curve in the drawing, and then take the time to look for it in photographs and paintings, you will find it quite often.

Another compositional form you will encounter frequently is the triangle. Again, it is only a rough form, a guide to make a composition more interesting, but it does work. Look for it in architectural photos, certainly, but also in figure studies, group portraits and nature photos. It is quite common.

The most important thing to realize when studying composition is that these "rules" are just guidelines, nothing more. Adhering to them too strictly will only produce photos which are boring and s tatic. The most interesting and exciting work being produced by photographers today often violates one or more of the "rules". The important thing is that the image works, not that it follows any pre-set guidelines.

10: Applications of the Hasselblad System

While it is impossible in this book to give a detailed course on every possible type of photography, I have selected some important photographic subjects to which the Hasselblad system is particularly well suited. It is my hope that the tips given will be useful to the reader interested in learning one of these aspects of photography. I give particular thanks to the professional specialists who have shared their knowledge with me in compiling this information.

WILDLIFE & NATURE PHOTOGRAPHY

It should come as no surprise that the Hasselblad camera system is well suited to wildlife photography, bird photography in particular, as this was the lifelong avocation of Victor Hasselblad, and one of the reasons for the development of the system in the beginning. Dr. Hasselblad contended that the equipment used contributed only 10% to the overall results, but arguments could be made for a higher number.

Although the novice wildlife photographer might suppose that the lenses most used would be the 500 and 350 mm, perhaps in each case with the 2X converter attached, in reality most of the best wildlife photos are taken with much shorter lenses. Even the 80 mm and sometimes the wide angles can be used if the photography is done from a hide or blind.

The hide is usually a small tent or sometimes a wood structure which is introduced into the natural environment of the animals to be photographed and left there until the wildlife accept it as part of the surroundings. This can take only a couple of days in some cases, weeks in others. It largely depends on how much the wildlife have been disrupted by man. Of course, in some locations such as Antarctica and the Galapagos islands, where man is not yet perceived as a threat, wildlife can be photographed at short range without a blind.

Once the hide has been accepted as part of the environment, it remains a problem to get into it without causing too much disruption. One old

trick relies on the fact that birds and animals can't count. In this trick the photographer and an accomplice walk quite openly to the blind and go inside. After a moment or two, the accomplice comes out of the blind and noisily leaves the area. If the photographer has remained quiet during this time, normal activity around the hide will commence again since the birds and animals feel that the disturbance has come and gone.

Most birds, and some mammals as well, have extremely keen eyesight. It is important the the camera lens protrudes from a slit in the blind at all times, the movement of withdrawing or extending it can disrupt behavior. It is also a good idea to use the longest possible lens hood which will not cause vignetting, since reflections in the glass front of a lens can resemble an eye and frighten wildlife. Equipment with a black finish, similarly, is less likely to cause reflections which may annoy or frighten wildlife. Many photographers cover the exposed chrome areas of cameras with black electrical tape or similar material to eliminate reflections.

For most wildlife photography a sturdy support is an absolute necessity. It amazes me how many photographers will invest a sizeable amount of money in a professional camera system and then hang it from a cheap, amateur tripod. The best tripod is not one a photographer is likely to enjoy carrying into the field. A good compromise must be struck between weight and sturdiness. Some of the best tripods I know of come from Benbo, Gitzo and Manfrotto (Bogen in the USA).

Often the photographer will decide that a remotely triggered camera is the ideal choice for a job. In this case the 500EL series of cameras has proved an ideal choice for remote operation, with a number of different options available for triggering. Formerly there were lenses available with automatic aperture control which could correct for changes in light, and these are still sometimes encountered on the used market. While they performed well, they were expensive and few were sold.

Today we can outfit the 205TCC for remote operation, confident that the exposure system will react to the smallest changes in light and keep the exposure accurate.

Sometimes the quest for wildlife photographs involves venturing into less than ideal climates. For use in extremely cold climates it is possible to have Hasselblad cameras and lenses "winterized", that is the normal lubricants are replaced with special low-temperature lubricants. These will allow the cameras to function in sub-zero temperatures and produce excellent photographs. It is important to have these special low-temperature lubricants removed if the camera is to be used later in normal

Modern architecture offers many picture possibilities, adding the person gives scale to the photo and humanizes the somewhat sterile, mechanical feel of this image. (Photo by Paul R. Comon).

temperatures, as they will not prevent camera wear at higher temperatures, and can vapourize and condense in unwanted places inside the camera. When using the battery powered Hasselblad cameras in extreme cold accessory battery packs are available which connect to the camera by a cable and allow the batteries to be kept inside the photographer's warm clothing.

Above: This unusual portrait was produced in the studio by Don Pas with a simple studio sweep background, a single prop, and a very understanding model.

Right: In wedding photography, the setting can be everything. Look for unusual locations for these portraits. (Photo by Wayne Tang).

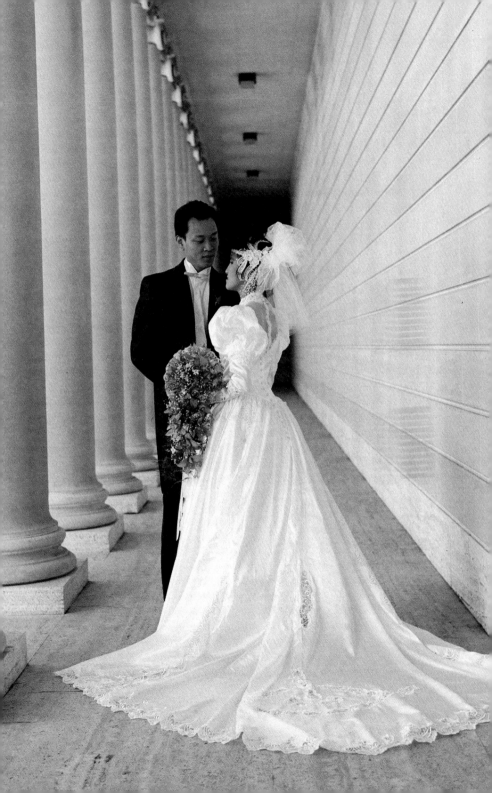

When moving from an extremely cold and dry environment into a warmer and more humid one, such as coming into a trail cabin, condensation will form on the camera and lens if not prevented. The best prevention is to put the camera and lens into a plastic bag, or wrap it in plastic wrap, while still out in the cold. This allows the condensation to form on the outside of the plastic rather than on the camera. External condensation is a nuisance, since the camera is useless until it evaporates, but internal condensation can cause serious problems from rust and corrosion.

Film winding should be done slowly in extreme cold because the film will be stiffer and less flexible and can even become brittle, and rapid winding-on of film can produce static electricity discharges within the camera which will produce traces looking like bolts of lightning on the surface of the film.

It seems that wildlife photographers are creatures of extremes, when not photographing in extreme cold and low humidity, they are photographing in the steamy heat of a tropical rain forest. High humidity exacts its own toll on camera equipment, causing rust and corrosion if not countered. The best way to keep the equipment free from moisture damage is to store it when not in use in an air-tight safe or storage container with packets of silica gel to absorb the moisture. The best silica gel is the indicator type which changes color when saturated with moisture; once the color change tips you off that it is saturated you can re-vitalize it by putting it in an oven. Follow the manufacturer's recommendations for best results.

Another problem usually seen in damp environments afflicts lenses. It is seen as a network of thin, spidery lines on the surfaces of lens elements and is caused by several types of fungi which actually feed on deposits on the lens surface and etch away the lens coating. If allowed to continue to grow, these fungi can cause damage which cannot be easily repaired. Zeiss manufactures a special cleaner which can be used to remove the fungi, but in severe cases it may be necessary to have the lens surfaces re-polished and re-coated, a very expensive proposition. Keeping the lenses in airtight storage protected by silica gel, and keeping dirt and oils off the external surfaces can both go a long way in preventing fungus damage.

Because wildlife and outdoor photography frequently involves taking photos on or near bodies of water, cameras sometimes do fall into the water. When this happens, get the camera out of the water as quickly as possible and dry off the outside. If the camera was completely immersed,

it is unlikely that no water got inside, no matter how quickly it was retrieved. To allow air to get to as many surfaces as possible, remove the lens from the camera body, take off the finder, take off the magazine, and remove the magazine insert. If you are near home, the balance of the water can be evaporated by placing the equipment into a warm oven, with the door slightly open, for several hours. However, this must be done with care so as not to get the equipment too hot, so the lowest setting must be used and the equipment must be checked frequently. If the equipment gets too hot to touch, it is being heated too much.

If the equipment should fall into salt water, do not try to dry it out as above without first purging the salt water with several changes of clean fresh water. It may hurt to dunk that expensive gear into a bucket of water, but the longer the salt water is allowed to remain in contact with the metal the worse the corrosion damage.

In either case, once the water is completely gone, check the equipment for operation. If everything seems to be working correctly it may be all right to use it for a few days until the trip is finished. However, even if everything seems to be working perfectly, it should all go to a good repair shop for cleaning, checkup and re-lubrication as soon as you return. Be sure to let the service technicians know that the camera has gotten wet, so that they can perform the necessary cleaning, checks and re-lubrication to get it back in top form.

Hasselblad cameras are remarkably tough. I have seen cameras which were soaked in salt water, left for weeks, and still revived, but not at small expense. Save such unnecessary expense by treating your equipment with care and protecting it from the elements whenever possible.

LANDSCAPE PHOTOGRAPHY

Many of the techniques involved in landscape photography are similar to those mentioned above in the section on Wildlife and Nature Photography. However, the landscape photographer is usually more involved with the broad sweep of nature, while the wildlife photographer is more interested in the smaller details.

Because landscape photography is often enhanced by great detail, this type of photography is well suited to the very high quality of the Hasselblad lenses. Often landscapes lend themselves quite well to square composition, as well.

Above: The Hasselblad is at home in the rigorous conditions of air-to-air photography as it is in the studio. (Photo by N. Evins).

Left: Nature photographers learn that they must get up early to catch photos like this. When shooting in the early morning, watch for moisture condensation on lenses and other optical surfaces. Once back indoors, do not put the camera into a sealed case until the moisture has had time to dissipate. (Photo by John T. Maxwell).

While some photographers use and recommend UV, Haze or Skylight filters to help cut through the haze in landscape photography, I have done side-by-side tests and can confirm that these filters have little or no effect when used with modern lenses. Most atmospheric haze effect is caused by UV light, and most modern camera lenses absorb practically all of the UV, making the filter superfluous. On the other hand, detail in distant subjects can often be enhanced with a polarizing filter, which eliminates excess glare. If you are shooting in black-and-white, a yellow, orange or red filter can cut through the haze, and the use of infrared film can do so even more. See the sections on Filters and Films for more information.

A very sturdy tripod is essential for excellent landscape photographs because such images are often made with slow films and with the lens stopped down to the smaller apertures to provide maximum depth of field. When taking color landscape photographs in dim light it is important to be aware of the reciprocity effect on films. The data sheet supplied with the film will specify color correction and exposure correction necessary for long exposures.

Often the landscape photographer is faced with the problem of a great difference in brightness between the land area and sky area of an image. There are several ways to deal with this. In earlier times, photographers using view cameras learned to use the film holder's dark slide or a piece of black card to dodge the sky area during the exposure. This is still possible when an exposure of one second or longer is required. Do not use the Hasselblad dark slide for this because it is reflective and may cause stray light to affect the image. However, a dark piece of card or paper, or at a pinch even the photographer's hand, may be used to darken the sky area. This is done by covering the upper part of the lens with the dodger and keeping it in constant motion during part of the exposure. If the sky is brighter than desired by one stop, then you would dodge for half the exposure.

This technique requires some practice for success, and is best used after this practice. I would also recommend a series of bracketed exposures for an important image. There is an easier way to do this now, and comes in the form of graduated neutral density filters. These filters are supplies in square or rectangular shape and have part of the filter transparent and part dark with a gradual shading between the two. By placing the filter in a holder attached to the lens, it is possible to adjust it so that the darkened part of the filter reduces the brightness of only a portion of the

image. The effect can easily be seen through the viewfinder, but it is important to realize that the effect changes with the aperture and thus must be viewed with the lens stopped down to the taking aperture. Many filter makers supply such graduated neutral density filters. Personally I have had excellent results from those made by Singh-Ray, which appear to be more neutral in coloring than most.

Because the Hasselblad Superwide cameras have become very popular with landscape photographers, the use of such filters with these cameras may be a problem. When used with the normal finder it is impossible to accurately view the effect of the filter, and it must be guessed. For critical work with the Superwides I would suggest the use of the focusing screen adapter with screen on the back of the camera so that the effect of the filter may be viewed directly through the lens. The folding focusing hood or other viewfinder will be necessary in most cases to mask the focusing screen from extraneous light and make viewing of the image possible. Just as with a view camera, the image will be upside-down and laterally reversed.

Of course, there are times when you may wish to impart a color to part of an image, and the filter makers also supply graduated color filters in a variety of useful colors. With these it is possible to add some color and interest to a featureless sky.

Remember, as well, that if you do your own darkroom work it is a relatively easy task to print in a sky from another negative if the sky in your landscape is boring. Many experienced black-and-white and color landscape photographers do this on a regular basis. For maximum believability it is important to use a sky negative taken on the same type of film, or at least one with a similar level of grain, and to keep the relative enlargement of the two negatives similar. Otherwise the disparity in grain size and structure between the two parts of the image can be unpleasant.

ARCHITECTURE

Architectural photography can be considered as a sub- category of landscape photography, and requires most of the same technique. Many architectural photographers use the Superwide cameras, and what I have said above about fitting the camera with the focusing screen adapter and screen applies even more to architecture because it is

Above: This image is strong because of the hard lighting, which throws the model's features almost entirely in shadow. The dark outfit and pose add to the feeling of strength and tension. (Photo by James Di Vitale).

Left: For their wedding album, the couple wanted a photo of the groom in uniform. Since he's a member of Canada's Royal Canadian Mounted Police, the uniform is striking, and the portrait on his horse produced an unusually colourful image. (Photograph by Ilija Galic).

important to align the camera to avoid distortion. This can be done with careful use of the bubble level, but I find it far easier to do so visually.

Hasselblad photographers have faced the problem of perspective distortion until recently because there was no shift lens available for the cameras. Hasselblad engineers studied the problem and decided that it made more sense to produce a shift adapter than to make a dedicated shift lens which would only provide one focal length.

However, to provide the needed optical distance behind the lens to allow the shift function, the adapter had to have optical elements and thus produces a small increase in the effective focal length of the lens in use. This was considered to be a small price to pay for the ability to use most of the lenses with a shift function. Also, the use of optical elements was necessary to increase the circle of coverage of the lenses so that the photographer did not experience vignetting of the image when the lens was shifted. Because a direct linkage shaft could not be used in the shift adapter, a double cable release is required to operate lens and camera body in proper synchronization.

Since this new accessory has just been developed, I am sure that architectural photographers will discover that it has many more potential uses than are evident immediately.

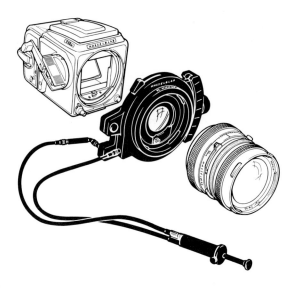

Zeiss PC Mutar 1.4x
Shift Converter for
Hasselblad

PORTRAITURE

Portraiture, both in the formal studio and more informally on location, has always been one of the strongest bastions of Hasselblad photographers. The speed with which the cameras may be operated to capture the most fleeting of expressions has always been one of the reasons that Hasselblad cameras are so popular with portrait photographers, the quality of the lenses is another.

When photographing people, typically either head and shoulders or the tight head shot sometimes preferred, photographers have always known that the "normal" lens rarely works well. The reason for this is that the perspective provided by this lens at short subject distances is all wrong. To provide proper perspective for a portrait, the photographer needs to be ten feet or more away from the subject, and to provide the tight cropping desired at that distance a medium telephoto lens is necessary. Portraits done with the 80mm lens will need to be photographed from only a few feet away for tight cropping, and at such close distances the subjects features will appear distorted, with the nose proportionally far too large and the ears far too small.

For this reason, practically all portraiture done with the Hasselblad system is done with lenses of 150mm and longer. I find the 150mm focal length just right for the bulk of the portraits I shoot. It gives a very pleasing perspective and can be used at its wider apertures to blur out a distracting background and emphasise the subject.

Some portrait photographers prefer a longer focal length, using the 250mm to give the perspective they like, and in some cases even longer lenses are used. This is largely a matter of the photographer's personal taste, but I would find working with a lens longer than 250mm impractical because of the great distance required between photographer and subject, and the more difficult handling always encountered with longer focal lengths.

Often in commercial portraiture, where the object is to flatter the subject, you will find that the Hasselblad lenses are simply too good. Their incredibly sharp and crisp images tend to render every line and crease, every wrinkle, in sharp detail. We often need to tone down this quality a bit to provide a portrait that our client will like. One of the best ways to accomplish this is with a soft-focus or diffusion filter. For years Zeiss has offered their own unique version of the soft-focus filter, called the Softar. I recommend that every portrait photographer purchase a set

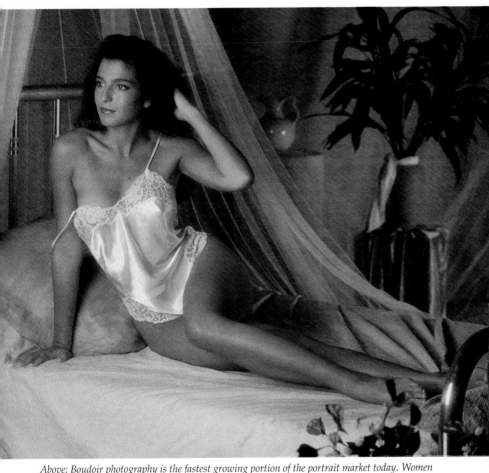

Above: Boudoir photography is the fastest growing portion of the portrait market today. Women want that special photo of themselves to give to their boyfriend or husband, or just for themselves. Studio settings and lighting for this sort of photography are best kept simple, the model's makeup, clothing and pose must be perfect. (Photo by Fay Sharpsteen).

Left: Photo by John T. Maxwell.

of these and keep them on hand. They come in three values, I, II and III, producing progressively greater degrees of softening. In the portrait trade I have often heard them referred to as "minus years" filters, with the number I being "minus 5 years" and so on. Generally you will not need anything stronger than the number III, but they may be stacked if desired.

The Softars work by producing a core sharp image and overlaying it with a soft image, so the overall effect does not look out of focus or too soft, as with some other filters. Remember that Softars are made from optical grade plastic, not glass, and are easily scratched, so take care when handling and cleaning them.

Other types of diffusion and soft-focus filters are sometimes used in portraiture, see the section on Filters for more detail about them. Portrait photographers also often use vignetters to produce a soft blending of the lower part of a portrait to black. This is done with a semi-circular piece of black material held in front of the lens and close enough to be out of focus, so that it causes a darkening of the lower part of the image. Such vignetters are available commercially, or may be made by the photographer from any suitable material.

White vignetters are also used, particularly in high-key portraiture. However, since the object is to create a fade to white effect, the vignetter itself must be illuminated. The easiest way to do this is with a small electronic flash unit held relatively close to the camera and directed obliquely at the front of the vignetter, usually from below. It will take some trial and error and test exposures to establish the best placement for the small flash, and one of the small flash units with a built-in slave trigger will be the easiest to use since it will require no PC cord connection and will be fired in synchonization with the main flash units.

FASHION & COMMERCIAL PHOTOGRAPHY

It is somewhat of a cliche' to say that in fashion photography the fashion of the photography changes rapidly, but it is nonetheless true. One fashion season will see sharp, clean, crisp images in vogue, while the next season may be nothing but soft, moody, grainy images. The working fashion photographer must be aware of these trends and follow them when necessary. Of course, each photographer must establish his or her personal style, and at times that style will be at odds with the fashion of the moment.

For this reason, fashion photography is one of the most competitive and difficult fields in which to make a living. There are some "old hands" in the business, however, who have weathered the changes and always seem to be able to come up with fresh images for the magazines.

Because the nature of fashion is to experiment, I cannot give any hard rules to the beginner. I personally find that fashion images shot with long lenses appeal to me, and I know photographers who normally shoot fashion with only the 350 and 500mm lenses, sometimes with the 2X Mutar as well. The reason for using such long lenses is that they produce a particularly flattened perspective and allow the subject to be isolated from the background with a shallow depth of field. They also allow the background to be greatly enlarged relative to the subject, which often makes it easier to produce good photos in cluttered surroundings.

Because fashion shoots tend to be fast-paced, active affairs, I consider a motor driven camera absolutely essential to this sort of photography. Because of the speed of operation, many fashion photographers have switched over primarily or almost entirely to 35mm camera systems, but with the motorized Hasselblad EL series cameras or with the motor on the 2000FCW or 205TCC these cameras are nearly as fast to operate as a motorized 35mm and produce the much larger image size.

Today's fashion photography often resorts to gimmicks, with transfers of Polaroid color images onto unusual substrates, processing of color negative films in chemicals intended for color slides, processing of color slide films in chemicals intended for color negatives, use of Polaroid instant 35mm films, and use of very high speed films which produce a grainy, soft effect all being popular at the moment.

I would not suggest that any photographer attempt to make a go of it in fashion unless that photographer is an experimenter at heart, and has a very good eye for fashion. At top level shoots the photographer will be assisted by a stylist, make-up artist, art director, etc., but it is still the photographer's eye which makes the difference between a great image and a merely serviceable one.

Today general commercial photography is a mix of anything and everything, to be successful in this field the photographer must have a very good grounding in the basics, and must know at least a little about many subjects.

All of the other disciplines discussed here can be adapted to commercial photography, and every lens and accessory in the Hasselblad system can be required for commercial shooting at one time or another.

Many Hasselblad camera systems are used in technical research. Here a specially made model airplane has been photographed in a wind tunnel to show dynamic stress patterns. (Photo by Eric Schulzinger, Lockhead Aeronautical Systems Company).

WEDDING PHOTOGRAPHY

Wedding photography is one of the most difficult of all fields. You are working with subjects who are involved in everything but the photography, are often difficult, and there are no opportunities for re-shoots if something goes wrong.

Practically all weddings can be photographed with only three lenses; the normal, the medium telephoto and the medium wide angle. Most wedding photographers I know who use the Hasselblad system carry the 50, 80 and 150 lenses. The 50 is used for the overall shots inside the church, and possibly for some broad shots of the reception. The 80 is used for the bulk of the photography, and the 150 is used for the tighter shots during the ceremony, during the reception, and for the posed shots.

Because the action at a wedding tends to be fast-paced and can be totally unpredictable, I consider a motorized camera a necessity for wedding shooting. However, the majority of the photographers I know who do wedding photography seem to use hand-cranked Hasselblads, and get along just fine. I suppose it is just a matter of personal style.

Practically all wedding photography is done with on-camera flash, and the advent of TTL OTF flash (see Chapter 8) has greatly simplified this by automating the exposure process. Just be aware that a white wedding gown may fool the meter if it fills most of the frame, and the same goes for a black tuxedo.

Since practically all wedding photography today is done on color negative films, and the new films are very forgiving, a lot can be done after the fact to correct for exposure errors. Even the most forgiving film gives the best results when correctly exposed, though, so don't allow the film latitude to cause you to become sloppy or careless about exposure.

Now that a new generation of ISO 400 films has appeared with excellent color fidelity and very fine grain, most of the wedding photographers I know have switched over to them. They allow faster shutter speeds for outdoor shots to better capture action, and for the flash photos they allow the photographer to use a less powerful (and smaller and lighter) flash, and to get more photos from a set of batteries or a charge on rechargeable batteries. I have recently tested new ISO 400 films from Fuji, Kodak and Konica and have found all of them to be remarkably improved over older ISO 400 films, featuring the color quality and grain that we formerly got from ISO 100 films.

TECHNICAL, SCIENTIFIC AND CLOSE-UP PHOTOGRAPHY

The Hasselblad system is a favourite of technically minded photographers because an extensive array of close-up equipment has always been a part of the system. The photographer needing greater than normal magnification has access to extension tubes, bellows, variable extension tubes, special lenses for these, and close-up lenses for fitting to the front of regular lenses.

Additionally, for use with such lenses as the Luminars and microscope objectives, there are lens mount adapters which can be machined to fit practically anything for use with the 2000-series and 205TCC cameras, and the microscope shutter for use with the 500-series cameras.

In the past it was difficult to accomplish close-up photography with correct exposure. Complex calculations were required to compute exposure. Today we have TTL meters for ambient light exposure determination, and TTL OTF flash systems for flash photography, both of which make such photography nearly as simple as everyday shooting. For those interested in exposure calculation, Hasselblad offers an exposure calculator as an accessory which works like a slide rule and gives just about any required data quickly and easily without the necessity for calculation.

GLAMOUR, BOUDOIR AND FIGURE PHOTOGRAPHY

In recent years boudoir photography has been the fastest growing aspect of commercial photography. Where there were no studios devoted specifically to this type of photography only a few years ago, now every town seems to sport one or more boudoir studios. Also, in years past most glamour and boudoir photography was taken to please the tastes of men, but today women are the clients and they are frequently having the photos taken for themselves.

A boudoir photo is a glamourous expression of a woman's physical sexuality, a provocative image of the subject as she wants to be seen. Producing such images is neither simple nor easy, a hard lesson learned by many who venture into this field without proper preparation.

All of the techniques of good portraiture come to bear on this type of photography, the photographer must have a very good understanding of lighting, exposure, posing, the use of filters and vignetters, and the use of props to convey a mood.

As a general guide, the entire preparation of the studio must be aimed at putting the model at ease and allowing the model to feel at home in an unusual situation. Many first-time boudoir posers will feel ill at ease, and the photographer must be willing to take the time necessary to get over this initial awkwardness and achieve the relaxed and natural atmosphere essential to producing a good image.

For the head-and-shoulders or torso boudoir images, most photographers will find the 150mm lens to work best. Generally, because the models are not professionals, some level of diffusion is used. Lighting is best done with large soft lights which produce a flattering effect and also do not require critical placement. This avoids distracting the subject and breaking the mood by having to re-set lights during the shooting. I normally use one quite large softbox to camera right at about a 45° an gle to the subject and a second, smaller, softbox to camera left, also at about a 45° angle, with a background light behind the subject when appropriate and a hairlight from above when needed to provide some separation. I typically use a lighting ratio of about 1:2 when shooting color transparency films for magazine reproduction, and will light things a little hotter (meaning a higher ratio) when shooting color negative materials for making color prints.

Glamour photography can be the same as boudoir, but boudoir is always intimate and nearly always shot in the studio, while much glamour photography is done on location. Glamour photos are generally not taken for the subject, but for a client such as a magazine, advertiser or calendar, and generally with professional or at least semi-professional models.

In recent years I have done quite a bit of glamour photography for clients around the world, and can speak from some considerable experience about the subject. I find the most difficult aspect of the field to establish the necessary intimacy with the model fairly quickly, while still maintaining the necessary professional distance. The photographer needs to have an open and friendly personality, but not so agressive as to intimidate or frighten the model. Such photographs can only work, can only be successful, if the model feels at ease and trusts the photographer.

I am constantly receiving letters and telephone calls from photographers who want to enter the glamour and figure photography field and want me to tell them how to find and work with models. My advice invariably is to first establish a level of professionalism so that the photographic part of the process is learned and comes naturally. Once this level of proficiency is achieved, it will be far easier to concentrate on producing the best possible images. When first beginning glamour shooting, it is best to work with a friend. Your first efforts may not satisfy you or the model, so don't make exaggerated promises at the start, just try to do your best to make the model look as good as possible. Once you have produced some reasonably good images with friends you can consider working with the professional or semi-professional glamour models. If you have problems finding friends who will model, or simply lack the self- confidence to ask, a good entry into the field is to attend one of the many glamour photography workshops now available. Here you can work with and learn from professional photographers and experienced models.

Glamour photography is nearly always in color, and to be successful needs to be very slick and commercial in appearance. I have found that the Fuji color transparency films, particularly the Velvia, provide the skin tones and color saturation which clients want in this type of photography. Kodak has also recently introduced films which are ideally suited to glamour photography, the Ektachrome 64X and 100X, which produce warm, pleasing skin tones and very saturated colors. Regardless of which type of film you use, these new films which produce very saturated colors also tend to pick up and exaggerate imperfections. Your model's makeup must be flawless.

Figure or nude photography could, in many cases, be considered a subcategory of glamour. Some photographers approach the nude human body with the same sort of perspective as the glamour photographer, producing a provocative, sensual photograph, while others take a more reserved approach, closer to the traditional fine arts feel. The choice of equipment and working technique will reflect the desired final result.

When photographing the figure with Hasselblad cameras, I have always taken somewhat of a purist's approach, keeping equipment and its involvement to a minimum, and nearly always shooting in black-and-white. Thus my outfit for the photos reproduced in this book was a 503CX camera body with 50mm and 150mm CF lenses (always with appropriate lens hoods!), several film magazines to speed up film change

Photos need not be needle-sharp to be effective. For this photo I wanted the effect of flowing water so I shot hand-held with the 150mm lens at 1/15 second. (Photo by Bob Shell).

and a Polaroid magazine for tests. At the time I was doing most of this photography the 205TCC camera was not yet available, so I did the metering with the Gossen Ultra Spot 1° spotmeter or with the Sekonic L-318 meter when I wanted an overall incident reading.

Because I like to be able to change camera position quickly, I use a monopod rather than a tripod to stabilize the camera. My film of choice is Kodak T-Max 100 when working in bright light, T-max 400 when working in shaded areas. Recently I have also begun to work with Ilford XP-2, and have found that it produces excellent results. Also, when shooting a traditional type of 400 speed film and wanting a little more latitude than afforded by the T-Max 400 (which is rather picky about exposure) I have begun to use the Fuji Neopan 400, which has just become available in 120-roll size.

Working with the nude model requires the utmost professionalism from the photographer. The model must be treated with respect and courtesy, and given frequent breaks because this sort of posing is often very tiring. If working in the studio, everything should be ready when the model arrives on the set; nothing breaks the mood of a shoot more than a photographer who has to endlessly fiddle with the equipment once the model is ready. If working outdoors, every effort must be made to ensure the model's comfort. Normally I carry along a cooler full of drinks and sandwiches when going for an outdoor shoot, and try to arrange for a break at least every half hour.

Whether shooting glamour or figure, the photographer must realize that this work is a collaborative effort between model and photographer. If the model is treated as a partner in the effort, if the photographer's purpose and intent is explained, the finished photos will reflect that feeling. The best accolade one of my photos can have is to be liked by the model who helped me create it.

Rendering the great contrasts between light and dark requires an excellent lens. All of the lenses for the Hasselblad system are the very best available. (Photo by Steve Anchell).

Whose bicycle? Why is he here? Where are we? Questions are raised and stories can be composed from enigmatic photos like this by Robert Ruschak.

184

Films for the Hasselblad

There are six basic types of film which may be used with the Hasselblad cameras. These are: 120-size roll-film, 220-size roll-film, 70mm perforated film, Polaroid instant films, sheet or cut film, and 35mm film. Each of these film types requires its own specially dedicated magazine. For information on proper loading and operation of the film magazines, see the chapter on Camera Operation. This wide variety of film magazines makes the Hasselblad system uniquely capable of using practically any film (or even glass plate) available today.

Almost all types of film which are available in 35mm size are also available now in roll-film sizes, although the variety is still much greater in the 120 size.

120-size roll-film is designed to produce 12 exposures with the normal 6x6 film magazine and 16 exposures on the 645 magazine. This film is attached with tape to a paper backing which threads from supply spool to take up spool. On the 120-size roll-film the paper backing runs the full length of the film, extending on either end to provide plenty of paper to provide light protection to the film on the spool.

220-size roll-film is of a similar type, but in this case the backing paper runs only just to the beginning of the film, where it is attached by tape, and at the end of the film a second paper strip is taped to the film to provide light protection once the roll is fully wound on to the take-up spool. Because there is no backing paper behind the film itself, the pressure plate of the 220 magazines is designed to press farther forward to keep the film flat and in the proper plane. Some photographers brag that they have used 220 film in 120 magazines, and vice versa, but the results will not be as sharp as they should be due to the incorrect pressure plate operation. 220-size roll-film is designed to provide 24 exposures with the 6x6 magazine, 32 with the 645 magazine.

70mm perforated film is basically motion picture film which has been adapted for still-photographic use. However, once many photographers started to use it the film manufacturers began to produce some specific still-photography films in this size. The variety is still rather restricted, but for some applications the 70mm film and magazine work wonderfully. There are three different types of 70mm magazines, each loaded and operated somewhat differently.

Sheet or cut film comes in a very wide variety of types and sizes. The Hasselblad cut-film holders, however, accept film cut to the 2 1/4 x 2 1/4 inch size only, so the sheet film must be cut in the darkroom to the proper size. Sheet film may be useful to the photographer in need of special film emulsions which are only available in sheets, or in situations in which film flatness is critical. Sheet film tends to stay flatter than roll-film because it has never been rolled. For technical and scientific applications, the Hasselblad sheet film holders may be used to hold **glass plates** (also cut to the 2 1/4 x 2 1/4 size) by removing the pressure plate. The sheet film holder is a seldom used accessory, but it is important to be aware that it exists for those special applications where only it will suffice.

Polaroid films have become a standard in the commercial photography industry for a variety of applications. When working on complex studio sets, only a Polaroid proof will assure the photographer that all of the lighting is set as desired, and that all equipment is functioning properly. Some photographers use Polaroid film as an "exposure meter" prior to exposing their transparency or negative films, but this is not really a very good idea because the Polaroid film is subject to a great many variables and may not produce a film speed index directly transferrable to another type of film. Polaroid prints can stand on their own as photographs, although those produced in the 54x54mm size in the Hasselblad are rather small. Polaroid also make positive/negative films which produce very usable black-and-white negatives from which high quality enlargements may be made.

35mm film. In response to customer demand, Hasselblad has produced the 35 film magazine. This magazine accepts standard 35mm film cassettes and produces a vertical image with 24x55mm dimensions. When used with one of the wide-angle lenses and with the camera turned on its side, this can be used to produce a sort of panoramic effect. I have used such a system and find the results quite useful when panoramic photographs are requested by a client. A standard 36-exposure load will produce 21 images in this magazine.

FILM SPEED

As mentioned previously, the sensitivity of the film you are using is one of the three important factors which determines the correct exposure

and produces pictures of professional quality. There used to be many different systems for rating film sensitivity, some film and light meter manufacturers even devised their own, and it was often difficult to cross reference from one system to another. Order was brought from this chaos by the adopting of two main systems. These were the geometric progression system of the American Standards Association and the arithmetic progression system of the Deutsches Industrie Norm. Unfortunately neither of these systems gained universal acceptance.

The American Standards Association system (ASA) is simple to learn and use and also easy to remember since it uses simple doubling and halving of numbers. A film with an ASA sensitivity of 200 is exactly twice as sensitive as one with a sensitivity of 100. Between each full step in the ASA scale there are fractional steps, normally divided into 1/3 step increments. Thus between our examples of 100 and 200 there are ASA speeds of 125 and 160.

In contrast to this system, that developed for Deutsches Industrie Norm (DIN) is not so easily learned or understood. The easiest way to remember this is that the DIN scale is based on degrees, and that three degrees added to a number exactly doubles the sensitivity while three degrees subtracted from a number cuts the sensitivity in half. Thus a film with a DIN sensitivity of 18° is twice as sensitive as a film with a DIN sensitivity of 15°. Adding one degree to a DIN number increases the sensitivity by 1/3 step, so this system is like the ASA in being based on 1/3 step increments. At one time most cameras were marked in both ASA and DIN numbers so it was no problem to set them from the film instructions regardless of which system the film maker used, but today almost no cameras have the DIN numbers so if you encounter film marked only in DIN you will have to convert to ASA. The table below gives this conversion for the most commonly encountered film speeds.

An attempt was made recently to integrate these two systems into a single system and this gave rise to the new system called ISO for the International Standards Organization which created it. Rather than coming up with a new system they decided to simply combine both of the old ones and use a composite number that takes both ASA and DIN and expresses them together. Thus a film with an ASA rating of 100 and a DIN rating of 21° would now have an ISO rating of 100/21°. However camera makers did not really take to this and almost all of them simply use the first half of the number, the old ASA rating, as I have done throughout this book.

When using films at other than the manufacturer's rated speed, it is incorrect to refer to this as an ISO number. As an example, if you "push" an ISO 400 film to 800, it is not correct to say that you pushed the film to ISO 800. The new number is properly referred to as an EI (exposure index) number, so you can properly say that you took an ISO 400 film and pushed it to an EI of 800.

Because the USSR was not a party to the ISO agreements, they have followed their own path and use their own rating system called GOST. It is an geometric scale similar in concept to the ASA scale, but having a different reference point. The GOST numbers are all about 1/4 step off from ISO numbers, so if you encounter a Soviet-made film with a GOST rating of 180 it will be identical in speed to an ISO 200. It is unlikely that this will be much of a problem to most readers of this book, but should you encounter and wish to use Soviet films, the reference table will make it possible for you to convert to usable ISO numbers.

Remember that if you are using unusual films while travelling, processing may not be standard and it may be impossible to have the films processed at home. This is unlikely to be a problem with black-and-white films, since they are reasonably standard no matter where they are made, but color films are another matter entirely. Because you can't know the quality and storage conditions of films bought during travel, it is far better to carry all of your film along with you and return it for processing.

Speed	ISO	ASA	DIN	GOST	Grain	Resolution
Slow	20/14°	20	14°	18	Very fine	Very high
Slow	25/15°	25	15°	22	Very fine	Very high
Slow	32/16°	32	16°	28	Very fine	Very high
Slow	40/17°	40	17°	36	Fine	High
Slow	50/18°	50	18°	45	Fine	High
Medium	64/19°	64	19°	56	Fine	High
Medium	80/20°	80	20°	70	Fine	High
Medium	100/21°	100	21°	90	Fine	High
Medium	125/22°	125	22°	110	Fine	High
Medium	160/23°	160	23°	140	Medium fine	Medium high
Medium	200/24°	200	24°	180	Medium fine	Medium high
High	400/25°	400	25°	360	Coarse	Medium high
High	800/30°	800	30°	720	Coarse	Medium
High	1000/31°	1000	31°	900	Coarse	Low
High	2000/34°	2000	34°	1800	Coarse	Low
High	3200/36°	3200	36°	2700	Coarse	Low

Any film which is marked "Process E-6" can be processed by a lab which processes Ektachrome, while any film marked "Process C-41" can be processed by a lab which processes normal color negative films.

One interesting option for photographs taken while travelling is to buy film with processing included (where available) or to purchase separate processing mailers from the film manufacturer. As the film is used during the trip it may be posted home (always by airmail or fast courier!) for processing and will be awaiting you on your return. The only times I would be uncomfortable with this arrangement would be when travelling in certain third-world countries in which the postal service may not be trustworthy.

Similarly, the working professional photographer can establish an account with a professional lab and post the film to that lab for pick-up on return. I have used such a system during my travels and have always enjoyed the ability to see my photographs immediately on my return from the trip. Generally I have used a courier service rather than the post office for this, the cost is greater but I feel more secure. However, when dealing with a courier, check the company's policy on film liability. Many will not accept any liability for lost or damaged film above the actual cost of the unexposed film, and some will not allow you to purchase insurance for increased value on such shipments. The working professional ought to have a private insurance policy covering possible losses.

BLACK-AND-WHITE FILMS

Even if you initially buy your camera with the intention of taking only color photos, I urge you to experiment occasionally with black-and-white. If you are considering setting up your own home darkroom, then it is always easier to learn developing and printing with black-and-white materials before progressing to color. Nothing you learn in working with black-and-white will be useless in working with color.

There are two reasons that most serious "fine art" photography is done in black-and-white. The first is that the reduction of colors to tones of gray abstracts an image, giving it a certain distance from reality, a distance which we frequently feel appropriate to art. Black-and-white photography is much the same as an etching or charcoal drawing in this sense. The form, tonality and composition must carry the picture - there is no crutch of color to support it.

The second reason that most art photography is done in black-and-white has to do with permanence of the image. While we know from direct experience that properly made black-and-white photos will last for over a century, we also know from unfortunate experience that this has not been the case with color photographs. It is simply a matter of chemistry. The image in a black-and-white photograph is made up of minute grains of metallic silver, and except for a bit of tarnish on the surface now and then this silver is non-reactive and practically eternal. As long as the prints are protected from atmospheric pollutants, particularly acids, prints made on modern black-and-white materials should be in very good condition in several hundred years. Many of the earliest photographs are still in excellent condition today.

In contrast, the image in color photography is made up of dyes. Dyes which lend themselves most readily to the photographic process are fugitive. Even under the best possible storage they will gradually fade, and under the usual storage conditions this fading is rather rapid. A visible change in color can usually be seen after only four or five years of ordinary storage. If exposed to sunlight or atmospheric contaminants this deterioration is greatly accelerated. Many of us who have been active in photography for a number of years can sadly bear witness to this deterioration in our early color photographs.

Although manufacturers boast of greatly improved dye stability in their most recent films and papers, even the most optimistic estimates do not claim that these materials will match black-and-white for permanence. For whatever reason, black-and-white photography should form a part of your photographic experience. Black-and-white films are available from most major manufacturers, but nearly all of them are similar enough to allow generalization.

Slow films. In situations in which maximum detail is important the slower films should be the choice.

There are two basic ways in which the film manufacturer can control the light sensitivity of a film. He can increase the light sensitivity by putting more of the light sensitive silver compounds into the emulsion and making it thicker and the grains larger, or they can control the shape of the grains during the manufacturing process to produce grains with greater surface area. In slow films manufacturers use a very thin emulsion and very small silver grains. The very thin emulsion allows the light to strike all of the silver grains easily without getting bounced around inside the gelatin itself, and the very small grains, after develop-

ment, give a smoother tonality to the image and allow the rendering of very fine detail. Film manufacturers refer to the amount of detail a film is capable of recording as the film's resolution. This is a numerical designation usually expressed in line pairs per millimeter and refers to the thinnest lines which the film can record as separate from white spaces of equal width in between. In the case of some of the slow films (sometimes called VTE films for Very Thin Emulsion) the resolution can be more than 300 line pairs per millimeter. This means that every millimeter of the film's surface can resolve or record 300 distinct lines or 300 separate bits of information. Such a film can be printed to normal enlargement sizes with incredibly fine detail and can be enlarged greatly without showing too much detail loss or grain.

In situations in which resolution of maximum detail is important the slow films should be your choice. These films are the ones with ISO ratings from about ISO 20 up to about ISO 50. Generally these films must be reserved for photography with the camera mounted on a tripod due to the slower shutter speeds they will require. The inconvenience of having to work with a tripod is offset by the much greater amount of detail these films are able to record.

Examples of slow (or VTE) films are: Kodak Technical Pan, Ilford Pan F, Agfapan APX 25, EFKE (ADOX) KB 14 and others. When working with these films it is crucial that they be processed in the correct developer. If you do not intend to develop your own film, make sure that the lab you will be using is able to properly handle these films. Generally you will have to go to a professional lab to find this service.

Medium speed films. Starting at about ISO 64 and going up to about ISO 200 are the films generally regarded as medium speed. You may find in reading photography texts that different authors make the distinction between slow, medium and fast films at different points on the ISO scale, and this is because there is no formal agreement on this point. My distinctions are based on personal experience and may not coincide with that of other writers, or with your own judgement. I regard films in my medium speed range as the best films for general use, with a good balance between apparent grain and film speed. Under the best conditions these films are capable of resolving about 100 line pairs per millimeter, but for practical use it is better to assume a resolution of about half of that. This is certainly more than adequate for most types of photography. Many lenses are not capable of producing images with resolution much greater than this, and of course the film can record no

more information than the lens projects onto it. If you plan to make very large prints which require that the grain be very fine and the resolution very high, then you have no choice but to use one of the VTE films along with an excellent lens, such as the 120mm Macro Planar.

Nearly every film manufacturer makes a general-purpose film in the range of ISO 100 to ISO 125. I have found all of the ones I have used to be very good and certainly capable of professional results if properly exposed and processed. Recent technical developments in emulsion design have allowed film manufacturers to control the shape as well as the size of silver grains in the emulsion. By using grains which are broad and flat, or multiple grain structure with grains inside grains, it is possible to greatly increase the surface area of the grains without increasing the quantity of silver. Films using this new technology are able to combine the characteristics of VTE films with the sensitivity of medium speed. The first black-and-white films to benefit from this technology are the Kodak T-Max films which use Kodak's proprietary manufacturing techniques to produce a broad flat grain shape which Kodak calls tabular (or T) grains.

From a practical point of view this has made it possible to approximately double the resolving power of the film while still maintaining a desirable film speed. Kodak's T-Max 100 can be handled like any other medium speed film but will produce prints with much finer grain and higher detail resolution.

Examples of other films in the medium speed range are: Kodak Plus-X, Ilford FP-4 Plus, Agfapan APX 100, EFKE (ADOX) KB21 and others. All have produced good results for me in the past.

Fast films start out at about ISO 400 and continue on upward to about ISO 3200 with normal processing. With special processing it is possible to achieve much higher film speeds, at the expense of much greater grain size.

For many years the two unchallenged champions in the 400 speed race were Ilford HP5 (now HP5 Plus) and Kodak Tri-X. Many millions of exposures have been made on both of these films by working photographers around the world. Although each has its proponents and they will argue long into the night about the relative merits of one versus the other, I have personally seen slight difference between them. I have always made my choice based on availability and price knowing that in either case I was working with a first class product. Agfa also produces a film in the 400 speed range, Agfapan 400, which I find to have an actual speed closer to 320 (developed as directed in Rodinal).

The higher speed films have also benefited from recent developments in emulsion technology. Kodak's new T-Max 400 is a film with a true sensitivity of ISO 400 but with a grain structure and resolving power formerly only found in the 100 speed class.

Ilford now offer the photographer a choice between two totally different 400 speed films. The traditionalist has HP5 Plus, a very advanced but standard formulation, with well-known characteristics, while the neophile has 400 Delta, an entirely new film with very fine grain, in most ways equivalent to Kodak's T-Max 400, but preferred by many users.

Fuji, well known for color films, has recently entered the black-and-white 400 race with a new film called Neopan 400 Professional. While it accomplishes somewhat the same thing as Kodak's T-Max 400, the Fuji film uses a different technology. In my tests with this film I have found that it produces a grain structure nearly as fine as T-Max 400 with the added asset of a longer tonal scale. What this means is that the film can record a greater range of subject contrast without either washing out highlight detail or blocking up shadow detail.

The highest film speed currently available in a general purpose black-and-white film is ISO 3200, produced by Kodak's T-Max 3200 P, available only in 35mm. This film is so light sensitive that it must be handled with extra care in loading and processing. Films with speeds this high must not be stored for prolonged periods of time as they will accumulate fog from cosmic radiation, even in cold storage. Such fast films are simply too sensitive for convenient long-term storage. Kodak has to store their bulk stock of T-Max 3200 P underground in abandoned salt mines to hold back this natural radiation fogging to a reasonable level. While it is possible to keep films of most speed ranges indefinitely in refrigerated or frozen storage, very fast films will be fogged regardless of such storage and should not be used past their marked expiry date.

Another special high-speed film is Kodak's Recording Film 2475, also available only in 35mm. This film produces prints with a very grainy appearance and rather low resolution, the film being capable of resolving only something like 25 line pairs per millimeter. Such a film can be used for artistic effect when you wish to soften detail and produce an abstract effect. It may also be used for photography in dim light where just getting a picture at all is more important than the quality of that picture. Police surveillance is one use for this film.

It is also important to know that the manufacturer's rated ISO speed may not be right for your own photography. It is best to make tests and

determine what speed works best for you. Many variables will enter into this, including the exact developer formulation used, the amount and type of agitation, the type of enlarger used, the paper printed on, and personal taste. Films will also vary slightly in effective speed from batch to batch, although such variation is not so great today as it once was.

With most modern films I find that my EI lies pretty close to the manufacturer's ISO rating.

Chromogenic black-and-white films. There is one special category of black-and-white films which should be mentioned here. These are the chromogenic or color- coupled black-and-white films. Currently there is only one representative, Ilford's XP-2. This film starts out much the same as a standard black-and-white film, but in addition it has color dye couplers linked-up with the light sensitive silver compounds in the emulsion. After exposure the film is developed in the same manner to produce metallic silver grains, but then the dye couplers produce clouds of dye around these grains, and during the rest of the process the silver, both developed and undeveloped, is completely removed from the film. Although both Ilford and Agfa introduced such films in the 1980's, Agfa gave up the race rather early on, and only Ilford continue to produce a chromogenic black-and-white film. At the time of writing the original Ilford XP-1 has been replaced with the XP-2, a vastly improved film.

Using the chromogenic system for image formation has allowed Ilford to produce a film with a nominal ISO speed of 400, but which can be exposed at a very broad range of effective EI speeds with no change in processing. Unlike the silver grain films, XP-2 produces finer grain at higher speeds, coarser grain at slower speeds. In my experiments, with standard professional lab C-412 processing, the best exposures fall within the EI 320 to EI 640 range, with EI 400 being smack on for most situations.

Because of its very broad latitude XP-2 has an incredibly long tonal scale, making it ideally suited for situations in which both very bright and very dim areas must be rendered with detail. However, this can also lead to difficulties when it comes time to make the prints because the tonal range of XP-2 so greatly surpasses the tonal range of any available silver-based paper. The best prints I have gotten from XP-2 have been on platinum/palladium sensitized papers, which have an equally long tonal scale. Perhaps the time is right for Ilford to introduce a chromogenic black-and-white paper to match the tonal scale of the film.

Because of the fact that XP-2 can be exposed at a variety of effective film speeds and still produce a printable negative, it has become popular with

many journalists who must shoot on the fly in very difficult situations. For this type of work it may be the ideal film.

ZONE SYSTEM AND FILMS FOR THE HASSELBLAD

Although it is not all that well suited to roll-film photography, I should briefly mention the Zone System as it relates to film and photography, because Hasselblad has made such a point of designing a Zone System Mode into the 205TCC. The Zone System is a method developed by Ansel Adams and his associates to match the contrast of a negative to the contrast of the scene being photographed. By means of altering both exposure and development, the contrast of the negative can be increased to deal better with a low contrast subject or it can be decreased to deal better with a high contrast subject. The important thing to remember about this somewhat complex and over-mystified system is that your light meter is adjusted to assume a middle gray of 18% reflectance which corresponds to Zone V in this system (the Zones are identified by Roman Numerals). If you are working with an average scene the assumption programmed into the meter will work very well. However, when you encounter a scene in which there is very little difference in brightness between the brightest and darkest areas the exposure set by the camera will produce a flat negative which will not print well on ordinary photographic paper. Under such circumstances the proper way to get the best negative is to increase the contrast of the negative, which would be done by decreasing the exposure and increasing the development time. On the other hand, if you encounter a situation in which there is too much subject contrast you would have to do just the opposite to lower the contrast of the negative. Personal experiment will have to be your guide. However, as I said this system is not very well suited to roll-film photography because you must expose and develop the entire roll of film the same way. The Hasselblad photographer can fully utilize the Zone System only by purchasing a minimum of three film magazines and devoting one to plus development, one to normal development, and one to minus development, but this precludes fine gradations in the plus and minus. You are unable to alter development of a single frame. This is the reason that the Zone System is most popular with photographers who use large format cameras and sheet film. The use of sheet film allows each

exposure to be made and developed to best suit the subject and the concept of the photographer.

Additional information on the Zone System can be found in any of the numerous books on the subject.

The reverse of push processing is pull processing. In this the developing time is decreased and the film is exposed at an EI lower than its rated ISO speed. I know of photographers who always use a film like Kodak Tri-X, normally rated at 400, but expose it at an EI of 200 or 100 and use pull processing. While this does produce finer grain and lower contrast than with the film exposed normally, I have never found it to have any advantage over just using a slower film at its normal rating.

COLOR FILMS

In the past photographers who shot in color for publication invariably used color transparency films because printers were equipped to make printing plates only from these films. Because this became so entrenched in the business, most photographers who shoot for publication still rely on color transparency films. However, this reasoning really no longer holds true.

Today printing plates for publication are produced by laser scanners which can scan either a color transparency or color print with equal effectiveness. Because color negative films generally have a greater exposure latitude and there is more possibility for personal manipulation in the print making process, many photographers have switched over to color negative material regardless of the end use intended. In the case of this book, many of the illustrations are reproduced from color prints and many are reproduced from color transparencies, and both have produced equally good results on the printed page.

COLOR TRANSPARENCY FILMS

Today there are three types of color transparency films generally available, distinguished by how they are processed. They are Kodachromes, the chromogenic color transparency films, and Polachrome (available only in 35mm) from Polaroid (which is dealt with in the separate section on Polaroid films).

Kodachrome films are direct descendents of the first commercially successful color film, the original Kodachrome. Kodachrome films are unique in that they are essentially multi-layer black-and-white films. Through a very complex developing process, colored dyes are added sequentially to the layers of the emulsion to build up the full color image. Because these dyes can be of stable types, Kodachrome films have much greater storage life than other types of transparency films. However, since the dyes used in Kodachrome are subject to fading from exposure to light, Kodachrome transparencies will fade much faster when frequently projected. During dark storage and normal light table viewing, the dyes are very stable.

While Kodachrome films have the dyes added during processing, all other current color transparency films have the dyes added as color couplers during the manufacturing process. Chemicals in the developer react with the couplers to produce the dyes, giving these films their name, chromogenic (color generating). Because dyes generated in this manner are inherently less stable than those added to Kodachrome, these types of transparency films have a shorter dark storage life than Kodachrome, but hold up longer under repeated projection.

Almost all films in the chromogenic category today are processed in the E-6 process pioneered by Kodak or its equivalent manufactured by Fuji, Agfa or another. Except for Kodachrome and Polachrome, almost any transparency film you may encounter today will be E-6 compatible.

PHOTOGRAPHING WITH COLOR TRANSPARENCY MATERIALS

As a general rule, color transparency films have a relatively limited latitude. For professional results, this latitude is frequently limited to less than one stop of over or under exposure. Properly exposing film with such a limited range requires a very precise exposure meter and careful metering technique. When working with the 1000, 500 or 2000 series cameras, a very good external meter or one of the Hasselblad meter prisms is absolutely essential for successful results with transparency films. Currently the extremely accurate light meter of the 205TCC is the best option for critically accurate exposure of transparency films.

Generally, color transparency films will tolerate underexposure better than overexposure, and many photographers have habitually under

exposed the film by as much as 1/2 step to achieve more saturated colors, on the theory that this produced better reproduction. However, times do change, and recent conversations I have had with members of the printing industry have convinced me that today's laser scanners will produce the highest quality of reproduction from a transparency which is perfectly exposed or errs slightly in the direction of overexposure.

The lesson in this for the professional photographer is to know your market and learn what they expect. There is no point in producing beautifully saturated dark transparencies if the client no longer wants that and instead would prefer the slightly lighter transparency.

The same goes for the choice between color transparency or color negative materials. In the past no magazine or book publisher would even consider color prints, and in many cases transparencies smaller than 6x6 would simply not be considered. Now the market finds 35mm transparencies perfectly adequate for most printed work (except for when the reproduction will be very large) and, in many cases, is perfectly happy to work from color prints. In my own magazine photography, I have passed through the stage when everything was automatically shot on slow transparency film to today in which I frequently shoot even fast 400-speed color negative films for magazine reproduction. The business is changing rapidly, so my best advice is for the working photographer to stay in close touch with his or her markets and follow the trends for what is desired.

That being said, I have to say that I still greatly prefer to photograph on color transparency films. The colors are so vibrant, and no print can match the brilliance of a perfectly exposed large transparency viewed on the light table.

Recently there has been somewhat of a revival in color transparency films, with some wonderful new films coming along from most of the major manufacturers. The following is a very personal series of opinions of currently available color transparency films.

Agfa: The current Agfa color transparency films come in a number of ISO speeds, 50, 100, 200, and 1000. While the slower of these films can produce very saturated colors, Agfa films in general tend toward a neutral rendition with more subtlety in their colors. When I want a very accurate rendition of colors, just as the eye sees them, I will frequently choose to work with the Agfa CT50 or CT100. For softer, more pastel colors, the faster Agfachrome films are hard to beat. Particularly the 1000 film for those times when soft colors and exaggerated grain are desired.

This film has become very popular with fashion photographers, you will most likely have seen its results in magazines.

Fuji: Fuji's range of Fujichrome tranaparency films have always been known for their saturated and somewhat exaggerated colors. When the color is the point of the picture and I want it punchy, I will reach for the green Fuji box. The Fujichrome 50D and 100D have become very popular with commercial photographers because of their brilliant colors. Now Fuji has added to the color saturation of their films even more and produced Fuji Velvia, which is capable of producing some of the most saturated and brilliant colors that I have yet seen. However, just because of this saturation and brilliance, Velvia is not the film of choice for day to day shooting. In many cases it is just too much, and a more subdued rendering is more appropriate to the subject. Used for the sorts of subjects it is right for, Velvia is capable of producing truly spectacular results.

Kodak: Kodak now produces three ranges of Ektachrome films in addition to the Kodachromes it has been making for years. In the general purpose 100 speed range, they now have Ektachrome 100 (EPN) which is an excellent film for accurate and neutral color rendition. For those photographers who want a bit more saturation and a slightly warmer color balance, there is Ektachrome 100 Plus (EPP). And for photographers who want even more saturation and an even warmer color balance, there is Ektachrome 100X Professional (EPZ). Of course, Kodak makes transparency films in other speeds, but the 100 speed seems to be the one used most general commercial photographers today and has received the most attention.

Of the three Kodachromes, 25, 64 and 200, only Kodachrome 64 is currently available in 120 roll-film size.

Konica: Konica produces only one color transparency film, Konica Chrome 100, which is available in 35mm and 120 roll-film sizes. It has the most accurate colors of any of the transparency films I have used.

Regardless of which brand of color transparency film you choose, one of the most important accessories is often one of the most ignored; the film data sheet packed in with each roll. It is important to learn to read this sheet, since there is sometimes very important information on it which could affect the results of your photography. Some films will deviate slightly from their designated ISO speed, and if so the data sheet will say so. Sometimes a particular batch of professional color transparency film will also deviate a bit in color balance, and this will be noted, with appropriate corrective filtration indicated.

Color transparency films are manufactured with the intention that they will be exposed within a certain range of shutter speeds. The reason for this is that the emulsion layers sensitive to different colors of light are exactly balanced to one another at only one specific light level, and will deviate from this balance as that light level is increased or decreased. In general photography this is not a problem, because the deviation is small enough not to affect overall color balance adversely. However, in dealing with very long or very short exposures the deviation may be great enough to produce a visible color shift. This failure of the film to respond in a linear manner to changes in illumination is referred to as reciprocity failure. The film data sheet also contains information on how to deal with this to produce proper exposure and color. Usually this involves increasing the exposure by a certain amount and adding corrective filtration.

Be advised that the information on the data sheet may not be relied upon for precise correction, it is only a suggested starting point for your own testing.

While practically all color slide films you will encounter are balanced for use with daylight or studio electronic flash which have about the same color temperature, there are other, special-purpose, color transparency films designed for exposure by other light sources. These are often designated by a **T** as part of the name, standing for Tungsten, the prevailing artificial light source. Such films are frequently used by studio photographers of still-life type subjects since they are intended for long exposure and allow the use of very small apertures for great depth of field. Most of the major film manufacturers offer at least one type of tungsten balanced film, and I have found that these films produce much better colors than daylight type films used with compensating filters.

Ordinary household lighting, while tungsten in nature, is not of a controlled color temperature like professional photographic lamps, so the color rendition produced on tungsten type films with these light sources is rarely accurate. However, for informal shooting many find the warm, golden rendition produced by this combination to be attractive.

Most color transparency films are offered in both amateur and professional versions. Generally there is little or no difference between the two. All films age in storage, and as they do the sensitivity of the emulsion layers changes slightly with respect to one-another. At a certain point in this aging process the film reaches its peak performance. Professional films are aged to this peak and then frozen to hold the film there. They

are intended to be stored by the dealer and photographer in refrigeration or cool storage until use, and then processed promptly.

Amateur films, in contrast, are sold while still a little "green" with the thought that they will ripen during the longer storage and time in the camera typical of amateur users.

With today's high standards of color tolerances, there is much less difference between the amateur and professional films than in the past, and many professional photographers I know use the amateur films with excellent results.

The only exception I know of to this general rule is the Fuji transparency films. In these films the amateur films are coated onto a transparent base appropriate to projection, while the professional films are coated onto a film base with a specific gray density to assist in good color separation for printing. I have spoken with printers and separators and they do tend to prefer the professional versions when working with Fuji transparency films.

COLOR PRINT FILMS

While there is little variation in color slide processing among careful labs, this is not the case with color prints. The same negative submitted to ten different labs for printing will often produce ten different prints, each one varying from the others in subtleties of color. The problem is a matter of subjective judgement. Even with great efforts at standardization, the final determination of whether the print is acceptable is made by the person doing the printing. Since the printer does not know what color your subjects were, beyond certain generalities, his judgement can lead to prints in which the actual colors are missed completely. This is particularly a problem when photographing unusual subjects which give the printer no automatic clues to proper coloring.

The automated printing machinery used in most labs is set up to assume all subjects average out to a medium gray. This means that negatives you have shot which ought to be printed with a much greater or lesser overall reflectance will be misprinted to average out to medium gray. Overall dark subjects will be printed too light and overall light subjects will be printed too dark.

To make matters even worse, these machines not only average tonal values out to an even gray, they also average colors! Large areas of a

single bright color will tend to be printed with too little of that color and the color balance of the rest of the print will be thrown off. As an example, I once did a series of nude photographs of a model against a bright crimson background. For reasons I can't recall I shot part of the session on color slide film and part on color print film. The slides were stunning with the colors just as I remembered them. The prints were a disaster. The background was printed in a pinkish-orange color while the model's flesh was rendered a ghastly blue-green color. It took three trips back to the lab to get these negatives properly printed.

Processing labs refer to this problem as "subject failure" to toss the blame for the problem back at the photographer. After all, if we'd all only cooperate by shooting average, boring photos the labs would never have this problem! Realistically, when shooting really unusual color situations it is best to use color slide film. If you must work with color print film, make sure to inform your lab of what you are doing. This is especially important if you are using "artistic" techniques such as double exposures, soft focus, trick filters, etc. because otherwise the lab is likely to assume that your art photos are just a bunch of mistakes and not print them at all.

Color negative films are available from a number of manufacturers and all of the ones I have used are capable of producing good prints in the hands of a good lab. The range of ISO speeds is broad, starting at ISO 100 and going up to 3200.

Color print films tolerate exposure errors better than color slide films. This is partly because the films themselves have more latitude and also because some correction can be done during the printing. Generally color print films tolerate overexposure better than underexposure, just the reverse of slide films. Just as many photographers rate their color slide films slightly higher in EI than the manufacturer's recommendation, many also rate color print films slightly lower. This often produces prints with more intense colors.

Generally the color quality of these films is better at the slower speeds, with the really fast films best considered special purpose films for shooting under bad lighting conditions. An exception to this is the Konica SR-V 3200 film which has remarkably good color for such a fast film. It is, though, rather grainy.

Color negative films come in both amateur and professional type. Generally, the professional 120 films are distinguished from their amateur counterparts by offering a slight "tooth" on their surface, a slight

roughness to allow retouching, and are often lower in contrast. Recent improvements in emulsion technology have allowed manufacturers to produce films with an ISO rating of 400 with very fine grain, about what we used to expect from ISO 100 films.

Another very interesting development is the Triade system of color negative films from Agfa; three films with very different characteristics which can be matched to the job at hand. The Ultima is rated at ISO 50 and produces bright, saturated colors and higher contrast. The Optima is rated at ISO 125 and is a general purpose film for most types of photography, with medium contrast and color saturation. Portrait is specifically made for working with skin tones, and features a softer contrast and less saturated colors appropriate to portraiture, with an ISO speed of 160.

During the writing of this book I had the opportunity to test a new film from Fuji called NHG, which is the perfect film for wedding and portrait photography. It offers a true ISO speed of 400 but with very fine grain and excellent color reproduction. The contrast is softer than general purpose films, but a contrastier version will also be available.

Since color print films account for more than 80% of all photos taken on a worldwide basis, there are many brands and speeds to choose from. All of the major film makers offer one or more varieties. My suggestion, if you intend to work with color print film, is to try several of the different types and then standardize on the one which produces the results you like the best.

INFRARED FILMS

At the end of the spectrum just past the visible red, begins a range of light, referred to as infrared (IR), which is invisible to the human eye. Infrared light will pass through optical glass and is brought to focus by camera lenses just like visible light. Special infrared-sensitive black-and-white films are used to record these images. At the present time, only Konica offers infrared film in 120 roll-film size, while Kodak offers their version in 35mm and sheet film sizes.

If you decide to experiment with some of this film make sure to follow the instructions carefully. You will have to load and unload your camera in the dark since the film backing paper and spool may not exclude infrared. If you intend to shoot several rolls of infrared in the field then

you will have to provide yourself with some means of loading and unloading the camera. A changing bag, available from photo dealers, will work so long as it is opaque to infrared.

You will also need some sort of protective wrapping to protect the film from fogging during storage after use. I have found that wrapping the film carefully in aluminium foil after removing from the camera, but still inside the changing bag, works well.

If you are not doing your own film processing make sure that the lab you plan to use is familiar with processing of infrared, since it requires careful handling in the darkroom. Since exposure meters vary in their sensitivity to infrared, there is no such thing as an ISO rating for these films. Your own personal meter setting will have to be determined by trial and error. The instruction sheet packed with the film will give you suggestions.

Infrared film also responds to some visible light, so it is necessary to block out most of the visible light to which it is sensitive. This is done with a number 25 red filter for general photography. Other filters may be required for specialized work, see the film instructions for details. You may find it difficult to focus through this red filter (and your TTL light meter may not work through it), so you may want to do your infrared photography on a tripod. You can then focus and meter without the filter and put it in place for the photos.

Once you have focused for the visible light, you will have to refocus for infrared because photographic lenses bring infrared light to focus at a slightly different point to visible light.

After you have focused the lens, look at the focusing scale. You will see a red line to the right of the center line. Move the focusing ring until the portion of the distance scale which was lined up with the center line now lines up with the red line.

It is best to work with small apertures where the focus is less critical, since the greater depth of field will cover any errors in focus.

It may sound like a lot of trouble to use infrared film, and it is, but the exotic and fantastic results which can be produced will more than justify the effort involved in producing them.

SUMMARY AND SPECIAL POINTS

All films carry a "use by" date on the packaging.If you buy close dated or outdated film, reserve it for experimental or less important projects.

Near the "use by" date on the film box is the emulsion number or batch number and refers to all of the film which was manufactured in one lot. While film may sometimes vary considerably from batch to batch, variations within a batch are always very small. For really critical work many professional photographers buy 100 or more rolls of film at a time, making sure that all carry the same emulsion number. They will then test a roll or two to determine the exact characteristics of that batch and freeze the balance of the film to prevent any change before it is used. While modern films vary little from batch to batch, there are often subtle differences in color balance and film speed which may matter to the very discriminating professional photographer.

One last special note about films. In recent years a totally new hazard has been added to our quest for best picture quality, the airport X-ray machine. All films are sensitive to X-rays just as they are sensitive to light. While most airports have posted signs stating that their X-ray equipment will not damage film, independent tests have shown that this is not true. Even if a specific type of machine is film-safe you may run upon one which is improperly adjusted and gives too high a dose of X-rays. Repeated passes through properly adjusted machines have a cumulative effect. Generally the higher the film speed the more likely it is to be damaged by X-rays.

In my travels I have found that most airport security personnel are polite and receptive to the request that photo bags be hand searched and not passed through X-ray machines, but there are still some countries which employ personnel who will refuse to honor such a request.

The best solution to this is to carry your film in special bags made from lead foil to reduce X-ray penetration. SIMA makes a product called Filmshield which is offered in several sizes of bags and also in rolls, and in two thicknesses, one for ordinary films and one for high speed films. While this product is opaque enough to prevent X-ray damage it will still pass enough X-rays to allow the operator of the machine to see that the bag contains film. Lead-lined film boxes for the same purpose are made by POSSO.

9: Index